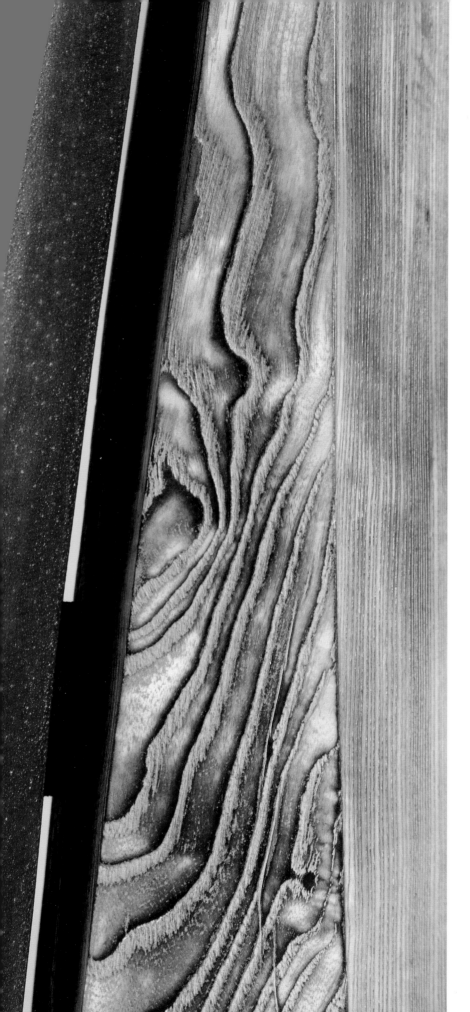

A Sense *of* Balance:
the sculpture of
stoney lamar

Asheville | **Art** | Museum

This book is published in

conjunction with the exhibition

A Sense of Balance: The Sculpture of Stoney Lamar

at the Asheville Art Museum,

April 13 – September 1, 2013.

ISBN 978-0-9700443-9-8

Title page: Stoney Lamar, (detail) *Standing in Forest*, 2012,
ash, steel and milk paint, 65 x 13 x 19 inches.
Courtesy of the Artist. Photo by Scott Allen.

Asheville | **Art** | Museum

contents

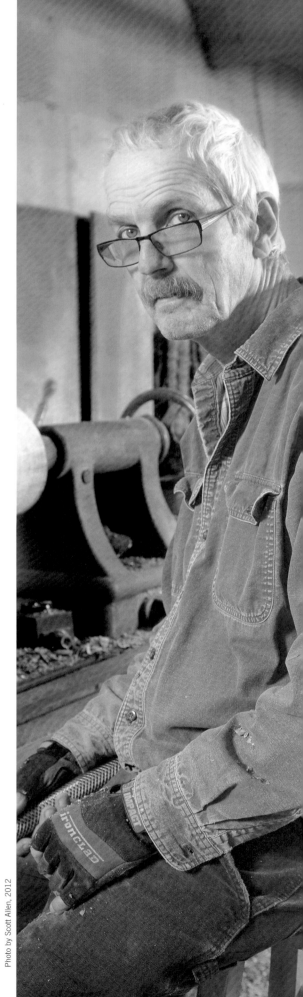

Photo by Scott Allen, 2012

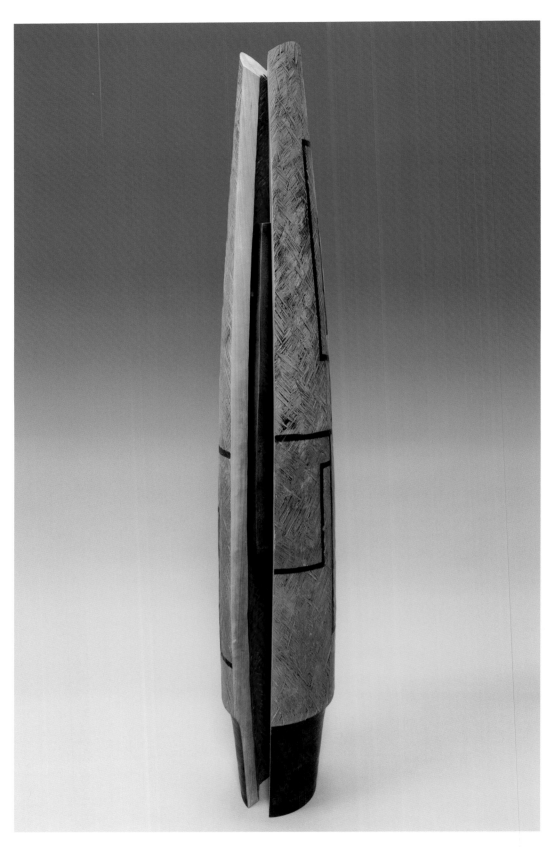

Sunshields, 2013, cherry, steel and milk paint, 66 x 10 x 8 inches.
Courtesy of the Artist. Photo by Scott Allen. Detail on right.

preface

I first became aware of using the lathe to create sculpture when working at the Southern Highland Craft Guild's Folk Art Center when we hosted an exhibition titled *International Turned Objects* in October 1989. Among the works was a wall piece by Stoney Lamar. I was instantly captured by the conceptual twist: that a turned object could be placed on the wall as if it were two-dimensional. In the ensuing years I would learn more about the art of turning and about Stoney's very particular place in that field. It has been an inspiration to work with Stoney and observe his creative process while curating this exhibition of his work.

As an artistic field largely populated by hobbyist turners, it is amazing to see Stoney's work in the larger context. He employs multi-axial turning and usually adds steel to the wood. His experience with both wood and steel has a depth that is at times breathtaking. He is also adept at working the surface of his pieces, using color as well as various carving techniques.

A Sense of Balance: The Sculpture of Stoney Lamar contains work from the early part of Stoney's career as well as the work that he has completed in the last year. As a curator it is a challenge to be both developing an exhibition and simultaneously assessing current work. This was made more challenging as a result of Stoney's diagnosis of Parkinson's disease in 2009. This monumental physical and emotional challenge has resulted in the strongest work of his career. The work has changed in both concept and scale, and in material and technique. This exhibition gives the viewer an excellent opportunity to view Stoney's entire career in one venue. From early vessels to current large sculptures sometimes augmented by the use of a chain saw, this exhibition is as much about achieving virtuosity in the face of enormous challenges as it is about the work. This combination offers us an unusual insight into the artistic creativity of Stoney Lamar.

My work on this exhibition was made possible not only by the generous contributors, but by Pamela Myers, Asheville Art Museum Executive Director, and by the tireless work of The Center for Craft, Creativity & Design Windgate Intern, Karen Peltier. I am also indebted to Howard Troxler and Matthew Hebert for their wonderful writing. For a catalogue of this scope, graphic design is of the utmost importance and I was so pleased to again be working with my talented friend David Guinn at Design One.

– Andrew H. Glasgow
 Asheville, North Carolina

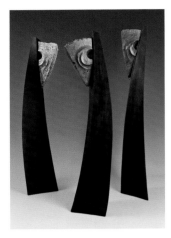

Cover: Stoney Lamar, (detail) *Moroccan Trio*, 2012, madrone, steel and milk paint, 72-76 x 12 x 14 inches. Collection of Charlotte Medical Center. Photo by Scott Allen.

Back cover: Stoney Lamar, 2013. Photo by Scott Allen.

On right: Stoney Lamar, (detail) *Standing in Forest*, 2012, ash, steel and milk paint, 65 x 13 x 19 inches. Courtesy of the Artist. Photo by Scott Allen.

Venues

April 13, 2013 – September 1, 2013
Asheville Art Museum
Asheville, NC

January – April 2014
Museum of Craft and Design
San Francisco, CA

May – August 2014
Los Angeles Craft and Folk Art Museum
Los Angeles, CA

October 2014 – January 2015
Arkansas Arts Center
Little Rock, AR

February – April 2015
The Center for Art in Wood
Philadelphia, PA

Major Sponsors
Blue Spiral 1
Fleur S. Bresler
Collectors of Wood Art
John and Robyn Horn
Marlin and Ginger Miller
Bill and Sara Morgan

Contributors
Anonymous
Cathy and Alan Adelman
Lin Andrews
Barbara Berlin
The Center for Art in Wood
Mignon Durham
Andrew H. Glasgow
Linda S. Haynes and R. Anderson Haynes
Bruce and Eleanor Heister
Charlotte and Raul Herrera
Nancy Holmes
The Judy Appleton Memorial Fund
Steve Keeble and Karen Depew
Barbara L. Laughlin
Jane and Arthur Mason
Wendy and Dale McEntire
Pamela L. Myers
Packard Woodworks
Rob Pulleyn
Mary Ann and Olin Sansbury
Barbara and Robert Seiler
Michael and Margery Sherrill
Randy Shull
Jamienne Studley and Gary Smith
Charlotte V. and Stephen A. Wainwright
Barbara Waldman and Dennis Winger
Ruth and David Waterbury

Lenders to the Exhibition
Arkansas Arts Center
Asheville Art Museum
Leann Bellon
Jeffrey Bernstein and Judith Chernoff
Fleur S. Bresler
The Center for Art in Wood
John and Robyn Horn
Charlene Johnson
Susan and Neil Kaye
Stoney Lamar
Jane and Arthur Mason
Leslie McEachern
Mint Museum of Craft + Design
The Museum of Fine Arts, Houston, TX
Francoise J. Riecker
Norm Sartorius and Diane Bosley
Barbara and Robert Seiler
Kenneth Spitzbard
Patricia A. Young

acknowledgements

Two roads diverged in a wood and I—I took the one less travelled by, and that has made all the difference. (*The Road Not Taken,* Robert Frost, 1916)

These famous words could describe the varied journeys of artist Stoney Lamar. The veracity of the connection is made clear in the illuminating essay by Howard Troxler which gives a sense of his personal paths, as well as in the essay by Matthew Hebert which places his work in a larger context and highlights the many key creative challenges and resulting decisions that, as an artist, he has made along the way. Guest Curator, Andrew Glasgow, teaches us how to see and about the wonder of seeing. Through his keen selection of works for the exhibition we understand that Stoney's work flows naturally from his materials, that his gift shows us the essence of sculpture which in the words of artist Isamu Noguchi is "the perception of space, the continuum of our existence".

Throughout the development of this important project it has been my great privilege to work closely with Stoney and to learn from him. He is an extraordinary and generous individual and artist. Not for a moment has he stopped making new work and challenging himself and those of us fortunate to be around him.

The Asheville Art Museum is firmly dedicated to the exploration of American art of the 20th and 21st centuries. The Museum also continues to focus on art and artists in all media who embody the rich cultural heritage and vibrant contemporary art scene in Western North Carolina. The opportunity to develop this project furthers our vision to transform lives through art and allows us to share Stoney's extraordinary body of work with others around the country.

Looking at art and talking with Andrew Glasgow, and learning from him and from collectors and makers John and Robyn Horn, Fleur Bresler and others, has been an invaluable experience. The exhibition and publication have been achieved through the support of many. The Major Sponsors of this project: Blue Spiral 1, Fleur Bresler, the Collectors of Wood Art, John and Robyn Horn, Marlin and Ginger Miller, and Bill and Sara Morgan, and the many Contributors listed on the facing page support artists through their work and their collecting, and their contributions to the Museum made this project possible. Their commitment is testament to the esteem in which Stoney and his work are held. Without generous Lenders, both individual and institutional, (listed on the facing page) who have shared works in their care, a project of this scope would not have been realized.

The Asheville Art Museum and all the members of the dedicated staff (listed later in the catalogue) were essential to the success of this endeavor. Special thanks must go to Karen Peltier, Curatorial Intern, who with the support of the Windgate Internship Program, has been coordinating the many varied details of this project and to Kathleen Glass and Melisa Holman who expertly managed communications and development. David Guinn, Principal and Creative Director of Design One of Asheville has used his many talents to skillfully create and produce this catalogue beautifully framing Stoney's work.

Finally I would like to thank the Asheville Art Museum's dedicated Board of Trustees (listed later in the catalogue) and the many Museum volunteers who are committed to presenting great art and great experiences and who believe in the enduring power and importance of art.

– Pamela L. Myers
 Executive Director
 Asheville Art Museum

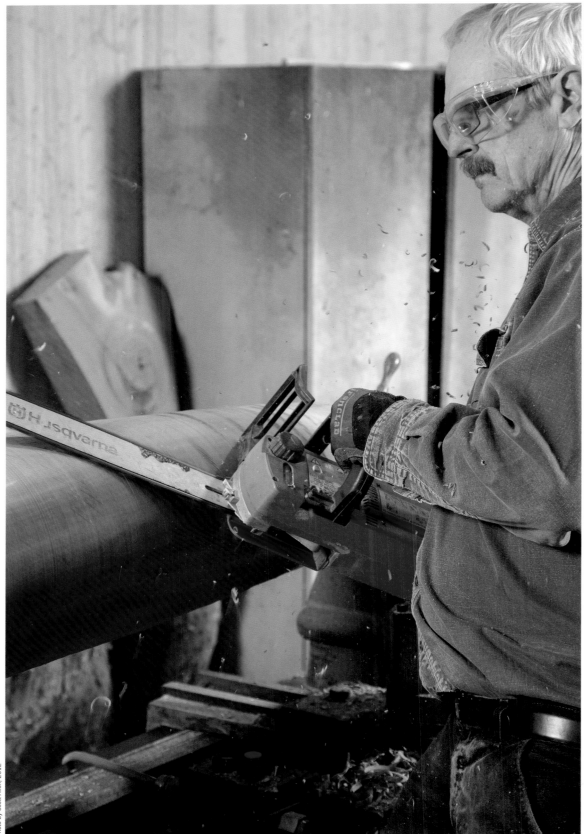

artist acknowledgements

When Andrew and Pam asked if I would be interested in this exhibition I was, of course, honored and somewhat surprised. I did not start out 30-plus years ago with this as a goal. I just wanted to make work, be a part of a community I believed in, and live the life that making would afford me. What I did not recognize at first was the powerful opportunity this invitation represents to reaffirm my belief in the power of making and the decision I made to become a maker. Because Western North Carolina is my home, I am especially pleased that this exhibition is opening at the Asheville Art Museum. I would like to thank everyone there for this invitation, for the exceptional work they have done, and most of all for the patience they have shown in dealing with my chronic lack of organization, most especially Andrew Glasgow, curator for this exhibition, Executive Director Pamela Myers, and Windgate Intern Karen Peltier. It is humbling to be a part of the fine artistic heritage the Museum has established, to be recognized from within my own community by such an institution, and to have the significant amount of support this exhibition has received locally and nationally. Most importantly I want to thank my wife, Susan Casey, and family for their continuous support.

Two years prior to this opportunity I was diagnosed with Parkinson's disease. Although I initially thought I did not want this exhibition to be about that, it proved impossible to escape the realities of this unwelcome guest in my body. I knew I had to change my approach to working and to move from a hands-on working style to one with more people involved, with my role becoming more of a director. To say I have learned a lot about communication would be an understatement. I would like to recognize two young makers who have worked through that process with me. While I have had other great working relationships in my studio throughout the years, Shane Varnador and Cory Williams, who have been with me for the last 18 months, have become my co-conspirators as we have produced new bodies of work. Without them it simply would not have been possible to produce even a fraction of the new work represented in this exhibition catalogue.

Finally I would like to thank the many people who have supported my work over the years—friends, patrons and colleagues. They could not have known, nor could I, that their support of my work was helping me to develop a set of skills that would be the best possible preparation for the challenges that are Parkinson's. For this I am eternally grateful.

– Stoney Lamar
 Saluda, North Carolina

Courtesy of Stoney Lamar

Photo by Scott Allen

Above and on left, Stoney Lamar,
Saluda, NC, February 2012.

9

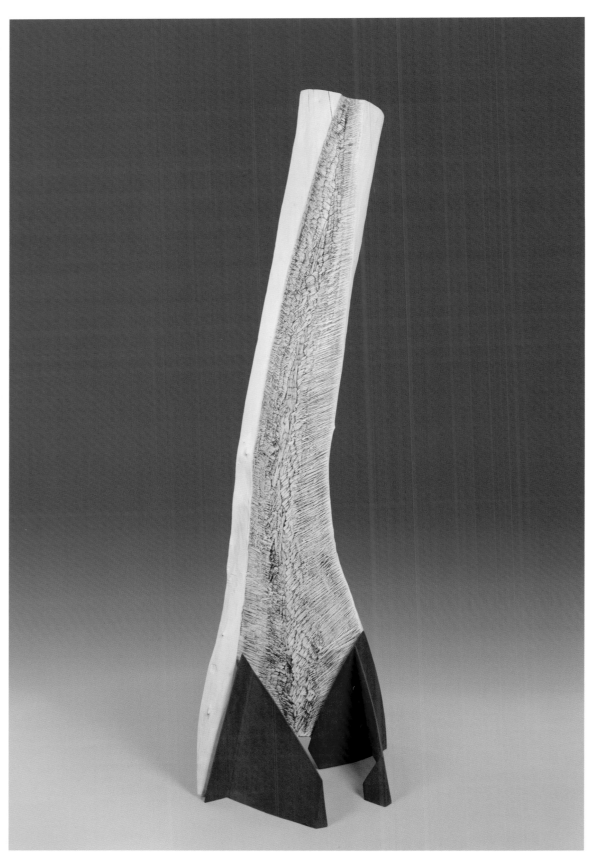

Assisted Inversion, 2012, walnut, steel and milk paint, 90 x 32 x 18 inches.
Courtesy of the Artist. Photo by Scott Allen.

serendipity

You could say that Stoney Lamar was preparing for his life's work as a maker even from his earliest years—that as a child he was fascinated by line and motion, enamored by the curve of form and the definition of space, that he grew into adolescence devoted to the study of his future craft, that by his manhood he was deeply versed in the theory and higher principles of art, and that ever after he grew steadily into the mature and remarkable artist whose work today is known, exhibited and collected across the nation.

You could say all of that.

But not much of it would be true. Except for the last part.

What is true is that no matter how striking, unique and evolutionary Stoney Lamar's career has been, he arrived at its beginning some decades ago by an entirely different path. He learned geometrical theory in a pool hall; he aggravated his minister-father; he grappled with a war; he set out in a career direction that he neither liked nor decided he was much good at; he almost by accident discovered what he was good at, at long last feeling the call in his hands and soul. And then—a second miracle—he found the one human being on the planet best suited to recognize it in him, and to put up with innumerable hardships along the way as his life partner.

Only then are we able to get back to the part about the remarkable artist whose work is known and exhibited, etc., etc.

There is something to be said for serendipity, or if you prefer, for fate disguised as such.

William Stoney Lamar was born November 26, 1951, in Alexandria, Louisiana, to an Episcopal priest and a onetime nurse. In a few years the family left for Knoxville, Tennessee, in the wake of church controversy—his father had allowed a black attendee to attend the church, which did not go over well in Louisiana in the 1950s. The family lived in Knoxville until Stoney was a high school junior, but by then he had been shipped off to a boy's school in Rome, Georgia, for discipline. Whether it was preacher's-kid syndrome or just an innate stubbornness, the young Stoney did not exactly strive to meet adult expectations. He recounts that: "I did get to be a pretty good pool shot, though." Even with his father's standing, the Episcopal schools would not put up with him either, so off to Georgia he went. "I think it probably saved my life," he says. "I guess I had never really been given any responsibility."

By his senior year in high school, Stoney's family moved to Tryon, North Carolina, in Polk County, not far east of the Pisgah National Forest, where his father had a new church posting. Stoney returned to local public school and did well enough to be admitted to the University of North Carolina at Chapel Hill. He says: "Everyone was stunned." Once there, however, he became intimately acquainted with the pastime of playing cards, and perhaps not as intimately acquainted with other things that he should have—leading, soon enough, to his no longer being a student at the University of North Carolina. His timing was lousy and his draft number was low. Called to service in Vietnam, Stoney instead spent two

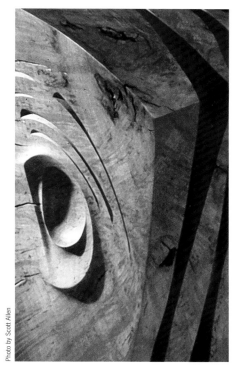

Stoney Lamar, (detail) *Muse Madrone*, 1996, madrone, 11 x 4 x 5 inches. Courtesy of John and Robyn Horn.

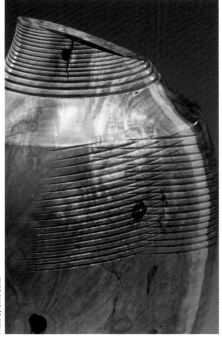

Stoney Lamar, (detail) *Last Vase*, 1996, maple, 18 x 8 inches. Courtesy of Charlene Johnson.

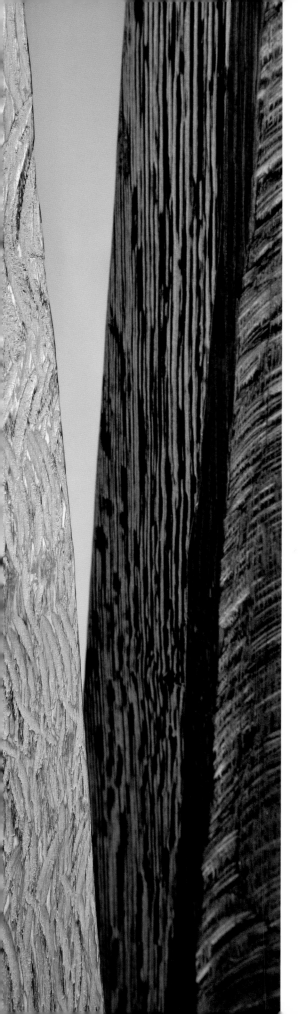

years to the day working as a conscientious objector, from September 13, 1971 to September 13, 1973. During this time he worked in mental hospitals and developed an appreciation of the thin line between "normalcy" and mental illness. "People are capable of building their own cosmologies, their own little world," he says. "And they're not all in hospitals."

A little older, perhaps slightly wiser, he enrolled in the University of North Carolina at Asheville and finally Appalachian State University, from which he graduated in 1979 with a B.S. in Industrial Arts. At Appalachian State University he met Susan Casey, the daughter of an Eastern North Carolina tobacco farmer, and once she decided to have him, they married with the romantic notion that they would make furniture together. "We were going to make furniture together, but we ended up making babies," Stoney says. "I thought I was going to be a furniture maker, too—but I didn't like making furniture."

He did not think of himself as a maker of art yet, not even the hint of one. But it was then that, for some reason, Stoney borrowed a friend's lathe and felt the rightness of it. Still, he did not suddenly smack himself on the head and declare himself to be an artist: "I didn't decide to be a sculptor," as Stoney puts it. "I decided to make work on a lathe." Fortunately, he was not an especially good bowl turner (according to him), or else the world today would have many additional so-so bowls, and far fewer Stoney Lamar sculptures. At last he began to really think about the lathe, to think about what it meant to geometry and line and the way that we see the world. Now the drive grew in him, he knew what he wanted to explore, and remarkably enough, Susan agreed to pack up their two young daughters and head to New Hampshire so he could serve as a wood turner's apprentice. By the mid-1980s Stoney and Susan were back in North Carolina, where he was creating work, being accepted to his first shows, and making early sales.

You cannot talk to Stoney about his early career for even a few minutes without him bringing Susan into the conversation. It was she who acknowledged the potential in him. It was she who not only allowed him to pursue his work, but encouraged it—demanded it. "You need to do this," she told him. And so for years they lived below the poverty level, with Susan working at a bakery, drumming up catering jobs or doing whatever else helped keep the family afloat. Ask Stoney for the secret of whatever success he has enjoyed as a creator and he replies: "What's really important is to be married to someone who doesn't have to help you cash a regular paycheck."

This is a biographical sketch, not a critical discussion of the work—there are others writing about that with considerable more ability and knowledge. Suffice it to say that Stoney has been exhibited constantly ever since, that his work is in public and private collections across the United States and beyond, that he has won numerous awards, that he has lectured, taught, and presided over workshops, and served as artist in residence. He has been a board member of the American Craft Council, president and board member of the Southern Highland Craft Guild, a founding member of the Association of American Woodturners and president of The Center for Craft, Creativity & Design. Among many other things.

Stoney Lamar, (detail) *Sea Grass*, 2012, white oak, steel and milk paint.
Courtesy of the Artist. Photo by Scott Allen.

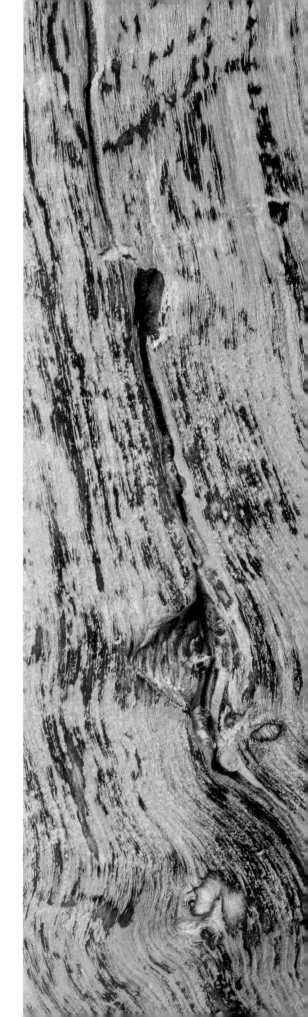

He produces his work in a studio in Saluda, North Carolina, located about 35 miles southeast of Asheville. Saluda is a city of 700 where his father had his final church and where he and Susan have lived ever since. In Saluda they raised two daughters in the house they built up the hill from the studio, and where they now preside over a growing flock of grandchildren with love and befuddlement. As his career evolved and his range expanded, so grew the shop's array of equipment—the drill presses, saws, winches, metal-benders, monstrous lathes, arc-welders, compressors, benches crowded with hand tools and walls of drawers. All manner of wood and metal pieces lean against the walls and fill the corners—work in progress, work abandoned, work under reconsideration, work that might or might not turn out to be interesting, work that has not yet not told him (as he puts it) what it is supposed to be. Lanky, gray headed, usually with goggles or a welding mask perched atop his head, Stoney at work gives the impression of a man puttering, and puttering more, absent-mindedly, but who is in fact deeply absorbed in the next decision to be made, before the next hard, physical, irrevocable putting of machine or tool against material.

This brings us to the current stage of Stoney Lamar's career, and its rather rude introduction. In 2009, he was diagnosed with Parkinson's disease and with it the inexorable, progressive loss of control of motion. Parkinson's is the cruel and perfect nemesis for a sculptor, in the way that a composer might go deaf or a painter blind. For an artist whose life's pursuit has been the captured expression of kinetic energy, the study of controlled line and frozen motion, what challenge could be more profound? Stoney himself wonders whether his creative self, his body and his subconscious, were aware that something was up long before any doctor told him, given that new themes of stability and instability, control and lack of control, had already begun to emerge in his work, seemingly of their own will. In the years since the diagnosis he has worked like never before, pushed his art to new places with new concepts, and has by general consensus produced some of the best work of his career. "Movement," he says with a wry grin, "has become increasingly theatrical." You can tell that he is honored, but also a little worried, by this whole career retrospective business, lest anyone confuse it for a coda or an ending. And rightly so.

Serendipity should be allowed to run its course.

– Howard Troxler
 Retired Columnist at the *St. Petersburg Times*

Stoney Lamar, (detail) *Bloom Too*, 2013, ash, steel and milk paint.
Courtesy of the Artist. Photo by Scott Allen.

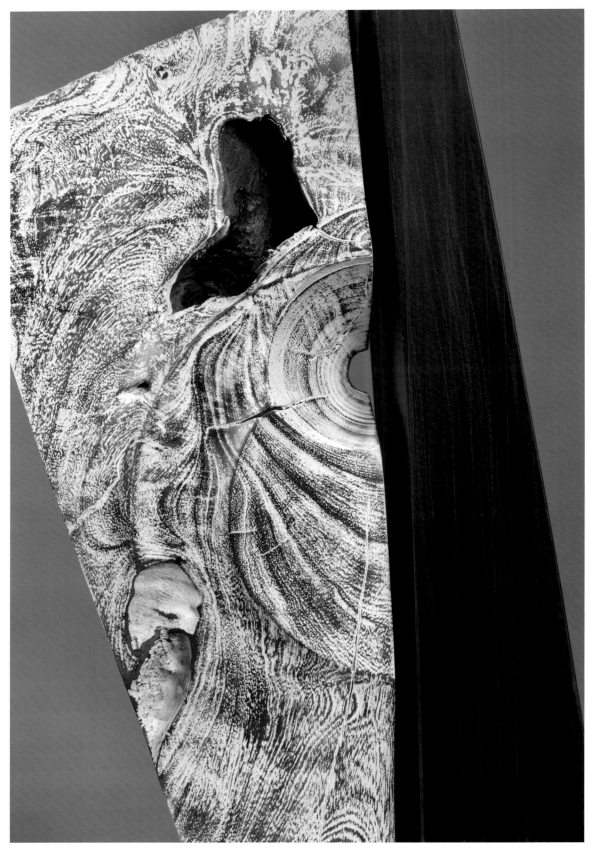

Stoney Lamar, (detail) *Second Watch*, 2013, carob, steel and milk paint, (one of two forms) 74 x 12 x 14 inches. Courtesy of the Artist. Photo by Scott Allen.

agressive serenity

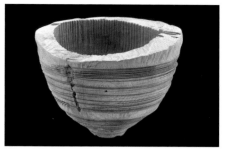
Figure 1

One shouldn't go to the woods looking for something,
but rather to see what is there.
- John Cage

The tensions between control and freedom, and between artist and audience are at the heart of many pivotal works of art. A particularly useful example is the composition *4'33"* by the avant-garde composer, John Cage. The piece, performed by pianist David Tudor, premiered at the aptly named Maverick Concert Hall in Woodstock, New York on August 29, 1952. The following is an observation of that performance:

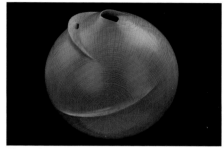
Figure 2

Tudor placed the hand-written score, which was in conventional notation with blank measures, on the piano and sat motionless as he used a stopwatch to measure the time of each movement. The score indicated three silent movements, each of a different length, but when added together totaled four minutes and thirty-three seconds. Tudor signaled its commencement by lowering the keyboard lid of the piano. The sound of the wind in the trees entered the first movement. After thirty seconds of no action, he raised the lid to signal the end of the first movement. It was then lowered for the second movement, during which raindrops pattered on the roof. The score was in several pages, so he turned the pages as time passed, yet playing nothing at all. The keyboard lid was raised and lowered again for the final movement, during which the audience whispered and muttered. [1]

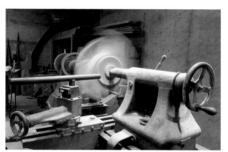
Figure 3

A few elements of Cage's most infamous piece help situate the work of Stoney Lamar within the larger history of art, as well as the specific field of studio craft. In essence, we find Cage groping for the limits of his art while simultaneously adopting a "Zen-like" repose towards the chance or risk inherent in his medium. Likewise, throughout the course of his career, Lamar has worked in a very sympathetic manner.

Lamar is an artist, whose chosen medium is not music, but wood, and whose primary technique is lathe turning. Lathe turning is believed to be one of the earliest machine manufacturing processes. In essence, it is a process that involves trapping a piece of wood between two points and rotating it around an axis, removing material with a sharpened steel tool laid upon a rest and fed into it. At its simplest, the technique creates revolved forms such as spindles. But, with a few tricks under one's belt, the operator can turn plates, bowls and vases. Interestingly, few things more efficiently encapsulate the liminal status of the studio craft object than the turned wooden object. That unique and technically dazzling, functional or quasi-functional object is often viewed atop a white pedestal at your friendly neighborhood craft gallery, museum or art fair. Turned items are curious as they cling to the craft tradition of virtuosically putting tool to material in order to create somewhat familiar objects, while simultaneously laying claim to the art object's alleged autonomy. This tension between an adherence to tradition and an impulse towards art's idealized freedom is central to much of the discourse on studio craft (see Glenn Adamson, *Thinking Through Craft,* 2007 and Howard Risatti, *A Theory of Craft: Function and Aesthetic Expression,* 2007), a field with its three feet firmly planted within the overlapping territories of art, design and craft. It is here, amid the tension among these three fields, that Lamar and his art flourish.

Figure 4

Figure 5

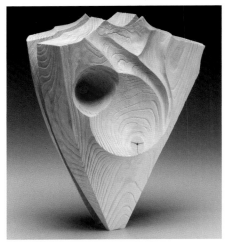

Figure 6

Figure 7

Lamar's beginnings as a wood turner and artist can be traced to when, at the age of 26, he began studying at Appalachian State University's Industrial Arts-Wood Technology program. The program was geared towards commercial cabinetry and Lamar quickly realized that he "didn't like to put things together." Instead, his lifelong interest in geometry drew him to the use of the lathe, which enables the subtractive process of wood turning. His interest in working with the lathe was stoked by a workshop at Arrowmont School of Arts and Crafts in 1982, which introduced Lamar to Mark Lindquist, a turner whose expressive sculptural approach has inspired many to move beyond the functional roots of lathe work (figure 1). The following year, a second workshop at Arrowmont would further fan the flames of Lamar's new passion. This workshop was headed by another titan of wood turning, David Ellsworth, a technically jaw-dropping turner who pioneered blind-turning, which allows for hollow forms with incredibly small openings (figure 2). Having found a conduit for his interests in the art of wood turning, Lamar moved his wife and two young daughters (then ages 3 years and 3 months old) north to work as an assistant in the studio of Mark and Melvin Lindquist in Henniker, New Hampshire. This experience was pivotal for Lamar's development as an artist. While working with the Lindquists he furthered his technical skills on the lathe, and most significantly, was introduced to the chainsaw as a means for making marks and forms in wood, both on and off the lathe. Invigorated, Lamar returned to Saluda, North Carolina, in 1985 to set up his own studio practice.

During my recent visit to Lamar's home and studio in Saluda, Lamar shared many anecdotes about his work and his family. I toured his studio and gallery and we ate many great meals at his and his wife's restaurant, The Purple Onion. During my stay, my mind kept returning to an earlier time spent with Lamar: specifically, a moment from Penland School of Crafts' Educator Retreat in September of 2011. The memory that played in my mind was of Lamar approaching a very large piece of wood turning on a lathe while wielding, not a scraper or a gouge, but a chainsaw. From my experience working and teaching with woodworking machinery, I can testify that a powerful fear is evoked whenever one approaches the lathe for the first time. The idea of sticking a razor-sharp piece of steel directly into a quickly spinning hard-edged piece of wood is truly unsettling, no matter what sense of control and confidence your ego and the tool rest offers. Yet, my memory is of Lamar with chainsaw in hand and remarkably serene.

Lamar has brought this aggressive serenity to bear on his impressive body of work. Dissatisfied with both the scale and form of the typical turned object, Lamar has spent the majority of his career gracefully pushing the edge of the technical envelope of the lathe (figure 3). He fuses the incredible sophistication of Ellsworth with the more expressive improvisations of Lindquist into a singular approach. His innovative technique is the result of many years of experimentation. During the late 1980s, he moved from a brief interest in turning vessels, to a focus on creating forms based on the intersections of geometric forms. In the late 1990s and early 2000s, he began incorporating different materials, primarily steel. Although he started to modify the color of his surfaces, primarily through bleaching in the 1990s, during the next decade there was a dramatic shift in Lamar's attitude towards surface treatment. In his current work, you are likely to

see wood that is treated with transparent or opaque color, burned, and otherwise altered. Mark-making is also an integral part of Lamar's current approach. In some of his most current work, Lamar leaves the wood raw.

In particular, Lamar's use of multi-axis turning and the impressively large scale of his turned elements have become hallmarks of his artistic practice. Multi-axis turning allows for the creation of complex geometry by working a piece of stock on the lathe, and then repositioning the material in a new orientation. In addition to incorporating multiple centers in a single piece, Lamar also employs a lathe technique known as therming. When therming, the operator mounts the piece on the lathe in such a way as to have the center of rotation outside of the object. Artists like Mark Sfirri and Michael Hosaluk effectively employ multi-axis turning in their work as well, but it is typically in the creation of objects that are more formally or visually self-contained (figures 4 and 5). By contrast, in Lamar's work, multi-axis turning serves a different end: it capitalizes on the bold geometric language of these turning processes to create elements suggestive of larger forms beyond the object. This is accomplished through the overlapping and incomplete nature of the different geometries (figure 6).

In addition to continually developing the physical aspects of his work, Lamar has also relentlessly explored the expressive potential of surface. While some wood turners may fall for their material completely, Lamar is not consistently reverent of wood. His early work shows a more expected respect for the beauty of wood, but through his explorations of bleached or painted surfaces, incorporation of steel, and more recently, mark-making, he has broadened his palette significantly. In particular, Lamar has incorporated painted surfaces to great effect in his work (figure 7). Yet, rather than stemming from an interest in over-the-top-expression, as is the case in some of his contemporaries' work, Lamar's stated aim is to use "paint as a means of un-deification." More importantly, I think it points to Lamar's interest in the viewer's role in the work of art. Much like the abstract formal elements, the expressive surfaces are visually ambiguous and draw the viewer closer to discern their qualities (figure 8). Indeed, Lamar has been known to remark: "the work isn't done until it's seen."

For any artist, especially one whose process is so physically demanding, life events will find their way into the work. Not surprisingly, being diagnosed with Parkinson's disease in 2009 has played a significant role in the development of Lamar's recent work. Even before his diagnosis, Lamar believes he may have been affected by the disease on an unconscious level, as his work reflects the physical instabilities that he experiences in everyday life. While Lamar long strove to make work that appeared as if it shouldn't stand up (figure 9), his more recent work has taken on a more stable appearance (figure 10), as he himself grapples to stabilize the tremors that can overcome him. Of particular interest is *Helix 1* (figure 10), which visually manifests the tension between control and deterioration inherent to Lamar's own struggle with Parkinson's disease. In these pieces, Lamar removes the pith and much of the interior of a section of tree trunk, creating an unstable situation where, due to the material properties of the wood, the wood will fragment over time. The pieces are also figuratively unstable: they don't seem to have an upward or downward orientation and they have a tenuous relationship with the floor. In order to resolve the sculpture, both aesthetically and

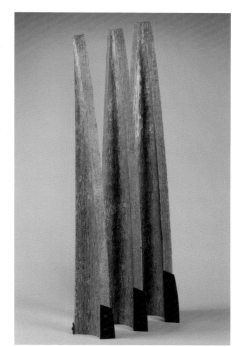

Figure 8

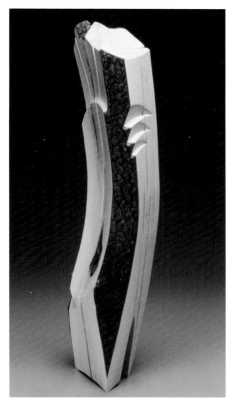

Figure 9

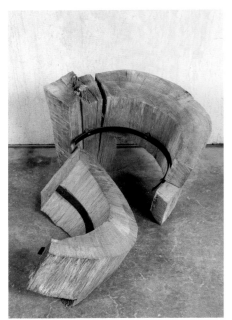

Figure 10

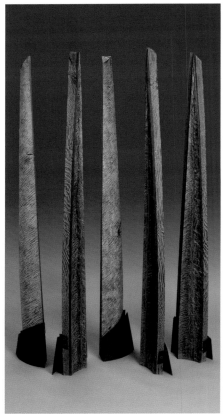

Figure 11

structurally, Lamar has added an interior spine: a band of steel bent to follow the interior surface of the form and bolted within.

Helix 1, as well as other recent pieces, serve as metaphors for Lamar's experience with his disease. Take, for example, *Shibori* (figure 11), which consists of a large conical split turning, similar to the forms found in *Blue Tree Shoes* (figure 8). In this instance, the interior surface is charred with a torch, and then marks are incised into the interior surface with a chainsaw. When discussing this piece in his studio, Lamar explains that he has been turning one of the symptoms of his disease into an opportunity for aesthetic expression. He explains that by setting his stance in such a way, he can allow the tremor in his hand, the Parkinson's symptom that he actively struggles to negate, to take control and guide the marks made by the saw. Indeed, I witnessed this struggle, during the demonstration at the Penland lathe that I discussed earlier. I recall being amazed that, as Lamar approached the lathe, the tremor that was just moments before contesting control of his right hand, had completely diminished. But rather than always control his tremors, he has found a way, at times, to embrace the uncontrolled movements. He has turned these subtle movements into chance operations—welcoming them into the palette of his work. Lamar has found yet another way to create art with an aggressive serenity—this time bringing a striking immediacy to the work. Just as John Cage sat quietly ushering all the "noise" of the Maverick Concert Hall and surrounding woods into his piece, allowing it even to become his piece, Lamar has developed all the parameters needed to highlight the universal tension between control and freedom.

– Matthew G. Hebert
 Assistant Professor of Furniture and Woodworking
 San Diego State University, School of Art, Design, and Art History

1 Solomon, Larry J., PhD. *The Sounds of Silence: John Cage and 4'33"*. Pima College, Tucson, AZ, 1998.

Figure 1: Mark Lindquist, *Ascending Bowl #3,* 1981, black walnut, 8 1/4 x 11 3/8 inches, photo courtesy of the Smithsonian American Art Museum.
Figure 2: David Ellsworth, *Mo's Delight,* 1993, white oak, 3 1/8 x 8 3/4 x 7 1/4 inches, photo courtesy of the Smithsonian American Art Museum.
Figure 3: Studio Photo, photo by Matthew Hebert.
Figure 4: Mark Sfirri, *Rejects from the Bat Factory,* 1996, mahogany, curly maple, cherry, zebrawood, cocobolo and lacewood, 37 7/8 x 25 3/8 x 5 5/8 inches, photo courtesy of the Smithsonian American Art Museum.
Figure 5: Michael Hosaluk, *Bowl of Strange Fruit,* 2009-11, wood and paint, dimensions variable, photo by Trent Watts.
Figure 6: Stoney Lamar, *Torso for WT (William Turnbull),* 1997, ash, 13 x 8 x 4 inches, photo by Tim Barnwell.
Figure 7: Stoney Lamar, *Assisted Inversion (detail),* 2012, walnut, steel and milk paint, 90 x 32 x 18 inches, photo by Matthew Hebert.
Figure 8: Stoney Lamar, *Blue Tree Shoes,* 2009, walnut, steel and milk paint, (each of three forms) 70-73 x 20 x 22 inches, photo by Tim Barnwell.
Figure 9: Stoney Lamar, *Torso of a Young Girl,* 1992, dogwood, 20 x 18 inches, photo by Tim Barnwell.
Figure 10: Stoney Lamar, *Helix 1,* 2012, white oak and steel, (each of two forms) 25 x 36 x 25 inches, photo by Scott Allen.
Figure 11: Stoney Lamar, *Shibori,* 2012, white oak, steel and milk paint, (each of five forms) 68 x 9 x 5 inches, photo by Scott Allen.

Stoney Lamar, (detail) *Bloom Too,* 2013, ash, steel and milk paint. Courtesy of the Artist. Photo by Scott Allen.

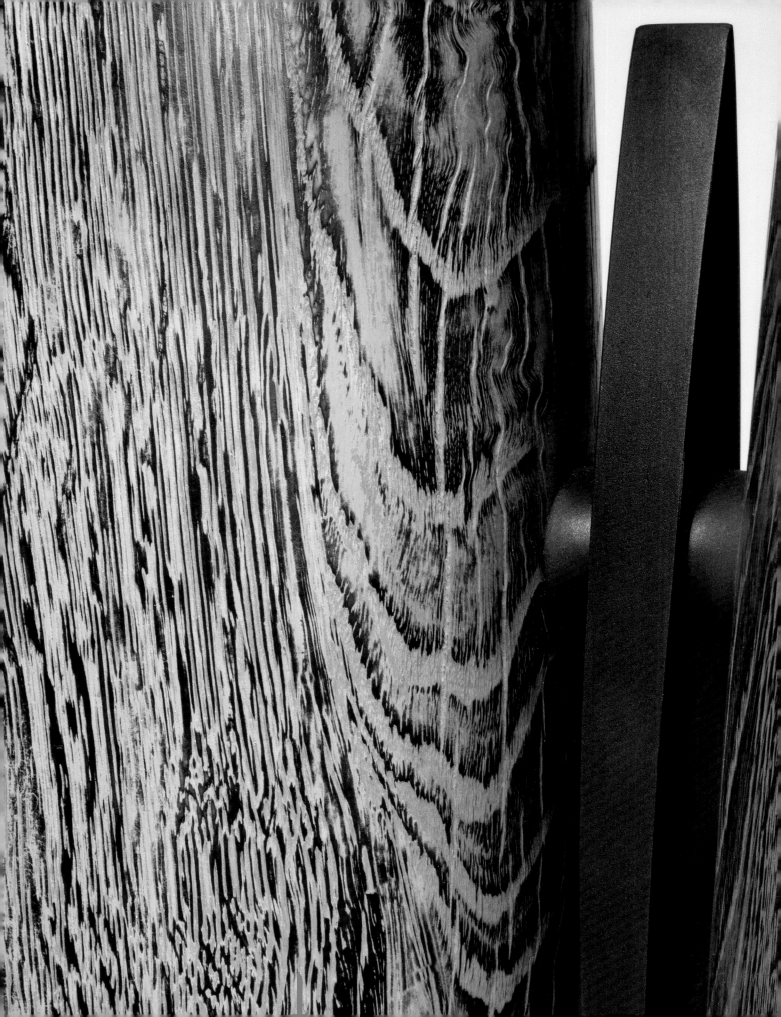

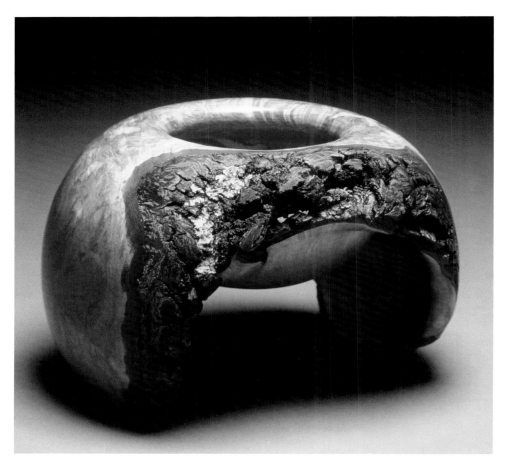

Suspended Vase Vessel, 1985, maple, 10 x 10 x 12 inches.
Courtesy of Leann Bellon. Photo by Chris Bartol.

Torso Reclining, 1987, walnut, 26 x 19 x 4 3/4 inches.
Courtesy of the Center for Art in Wood Musem Collection. Donated by Fleur S. Bresler. Photo by John Carlano.

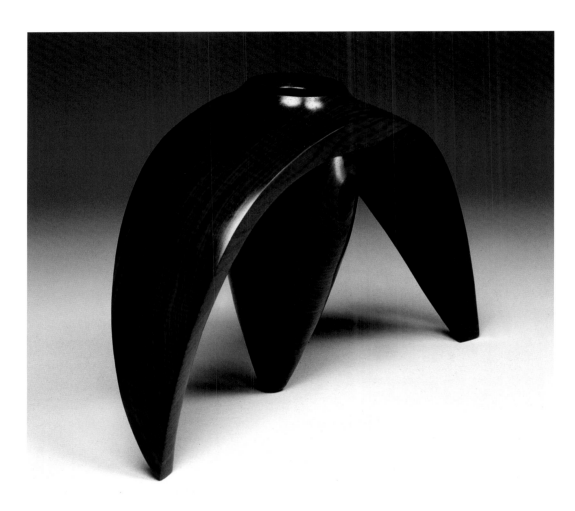

Suspended Wire Walker, 1988, cocobolo, 8 3/8 x 13 3/4 x 4 inches.
Courtesy of Fleur S. Bresler. Photo by Chris Bartol.

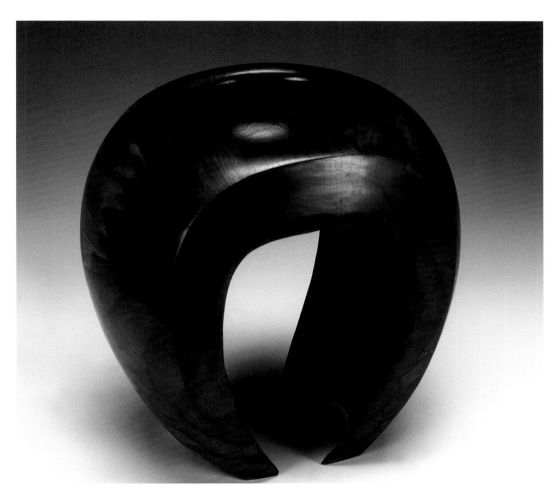

Suspended Vase Vessel, 1988, ziricote, 10 x 10 x 18 inches.
Courtesy of John and Robyn Horn. Photo by Chris Bartol.

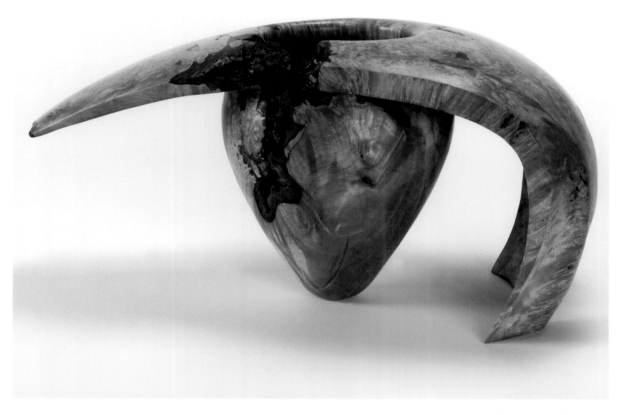

Indian Altar, 1988, maple burl, 8 x 10 x 8 inches.
Courtesy of the Asheville Art Museum. Gift of John and Robyn Horn. Photo by Frank Thomson.

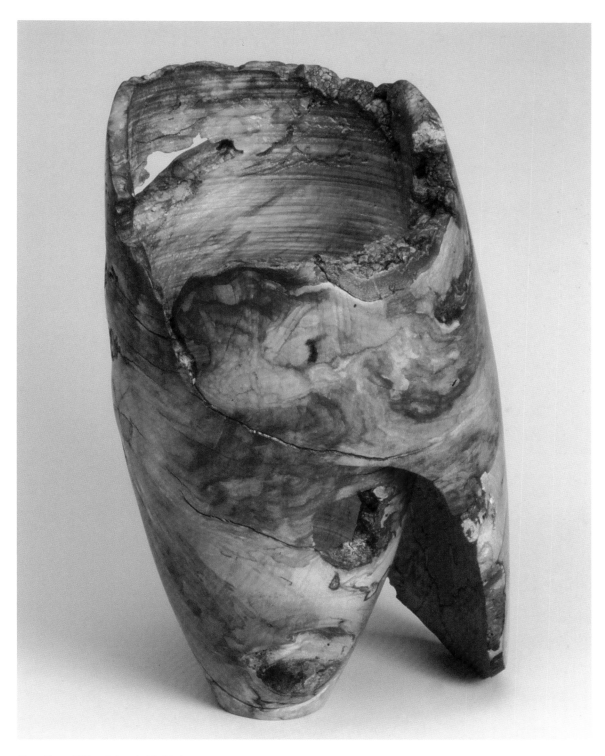

Open Form, 1989, spalted maple, 16 x 8 inches.
Courtesy of Susan and Neil Kaye. Photo by John Carlano.

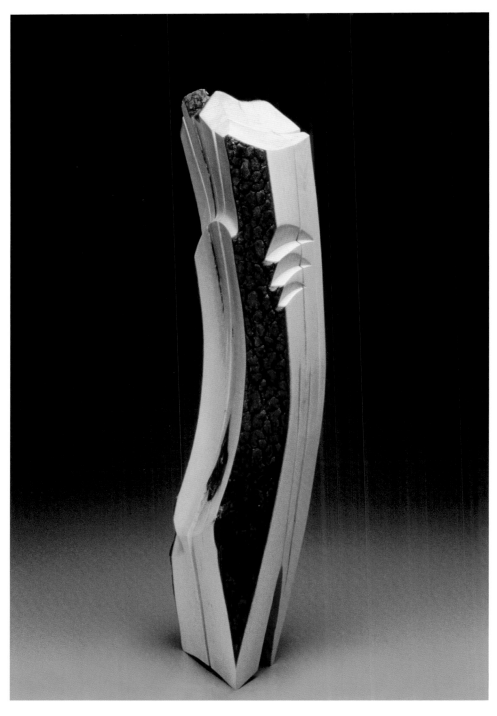

Torso of a Young Girl, 1992, dogwood, 20 x 18 inches.
Courtesy of John and Robyn Horn. Photo by Tim Barnwell.

Lady in Waiting, 1995, maple, 24 x 6 inches.
Courtesy of John and Robyn Horn. Photo by Chris Bartol.

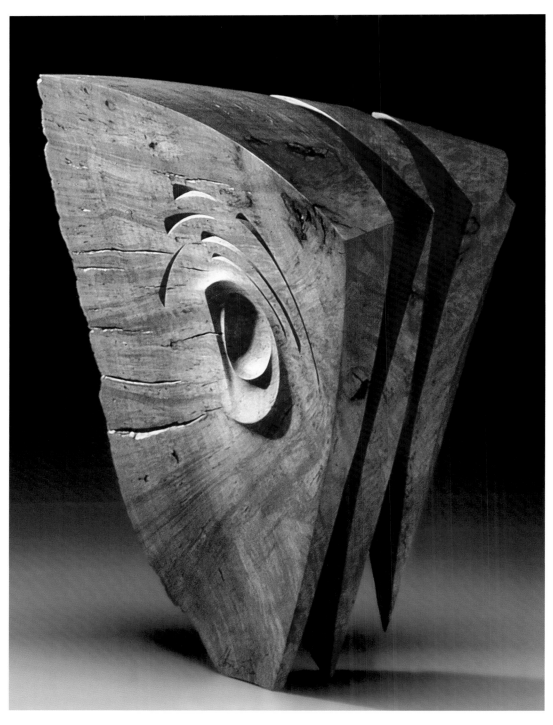

Muse Madrone, 1996, madrone, 11 x 4 x 5 inches.
Courtesy of John and Robyn Horn. Photo by Scott Allen.

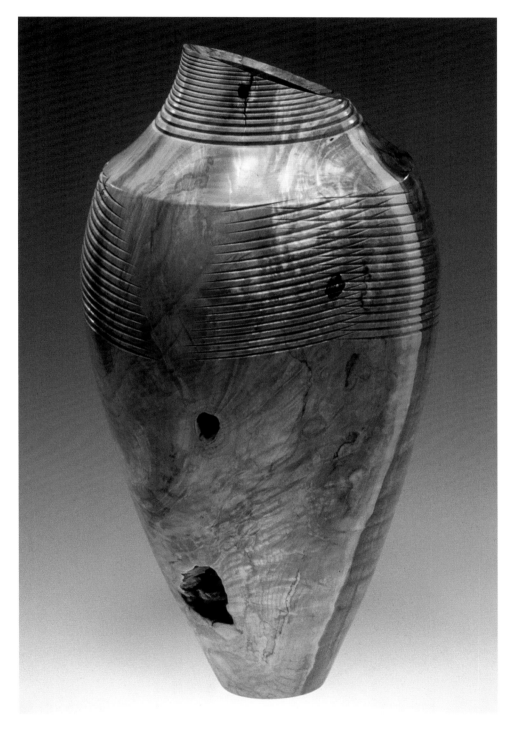

Last Vase, 1996, maple, 18 x 8 inches.
Courtesy of Charlene Johnson. Photo by Chris Bartol.

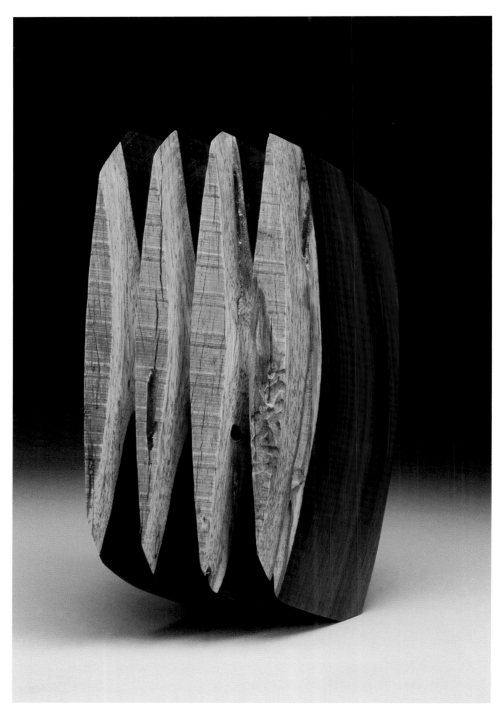

Addicted to Rhythm, 1996, 10 x 8 x 5 inches.
Courtesy of the Asheville Art Museum. Gift of John and Robyn Horn. Photo by Tim Barnwell.

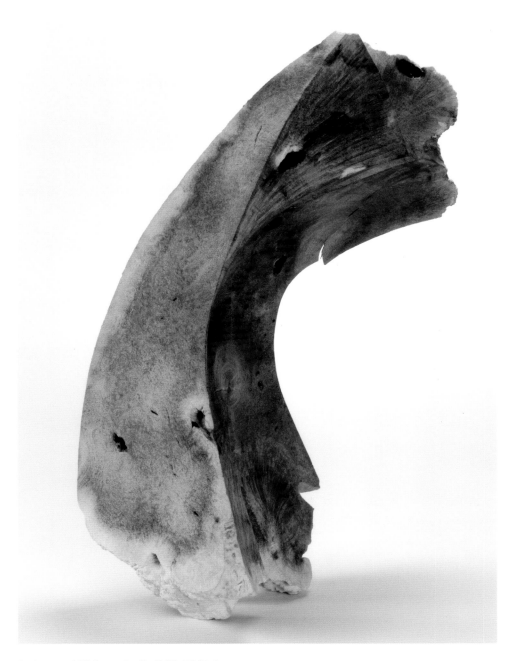

Let's Dance, 1996-7, mazanita, 16 x 10 3/4 x 7 7/8 inches.
Courtesy of Fleur S. Bresler. Photo by Chris Bartol.

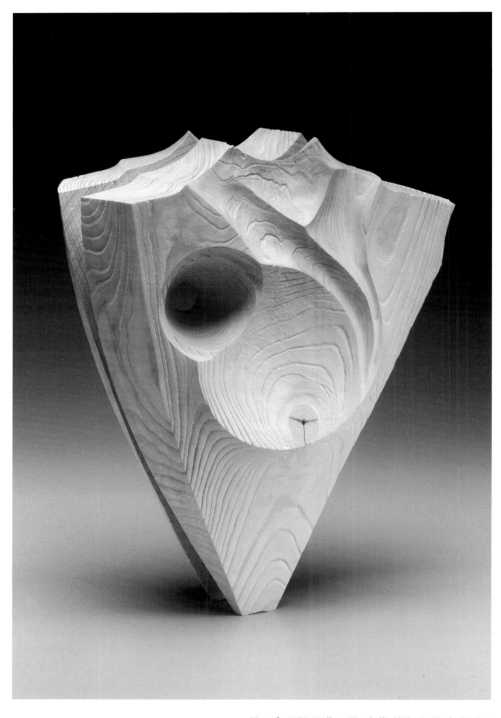

Torso for WT (William Turnbull), 1997, ash, 13 x 8 x 4 inches.
Courtesy of the Asheville Art Museum. Gift of John and Robyn Horn. Photo by Tim Barnwell.

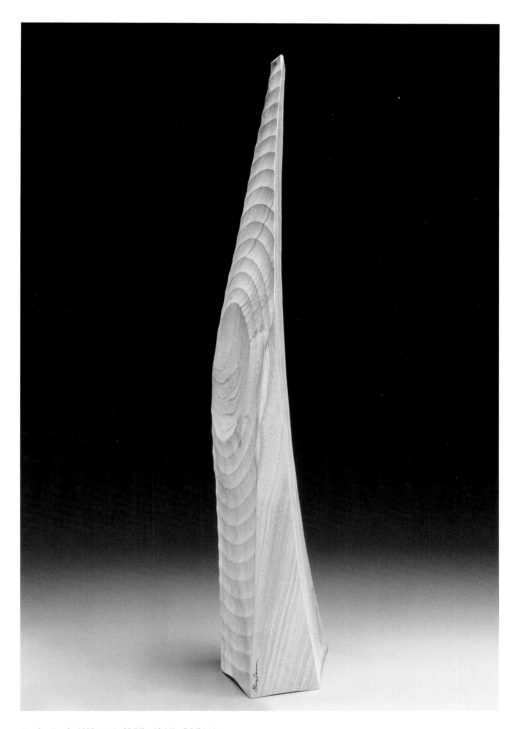

Spider Rock, 1997, carob, 22 7/8 x 18 1/4 x 7 3/8 inches.
Courtesy of Fleur S. Bresler. Photo by Tim Barnwell.

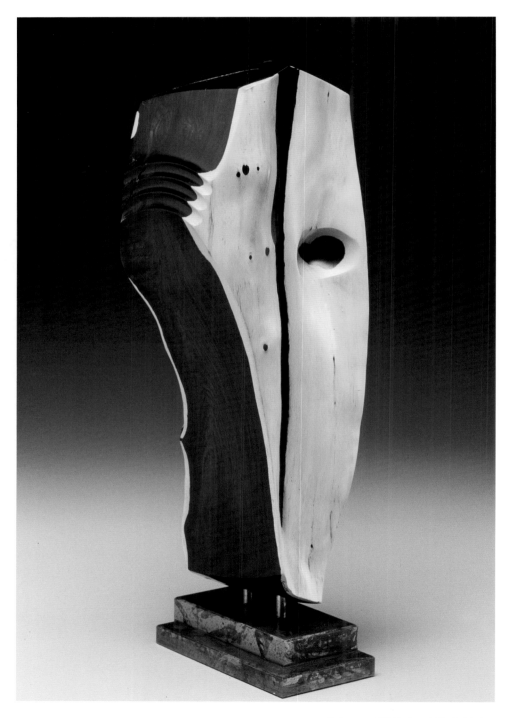

Reliquary, 1998, blackwood, 20 x 5 x 5 inches.
Courtesy of John and Robyn Horn. Photo by Tim Barnwell.

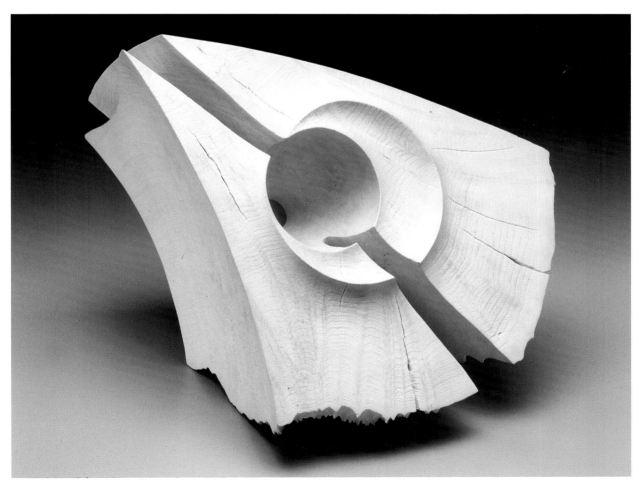

White Line, 1998, bleached madrone, 11 1/4 x 14 x 8 inches.
Courtesy of Kenneth Spitzbard. Photo by Tim Barnwell.

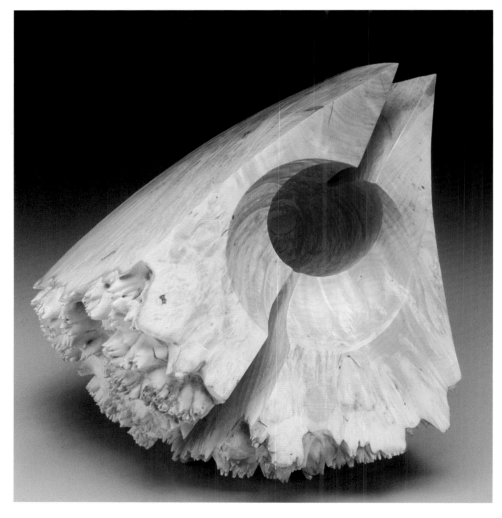

Maple Vector #1, 1998, maple, 11 x 12 x 12 inches.
Courtesy of Mint Museum of Craft + Design. Gift of Jane and Arthur Mason. Photo by Tim Barnwell.

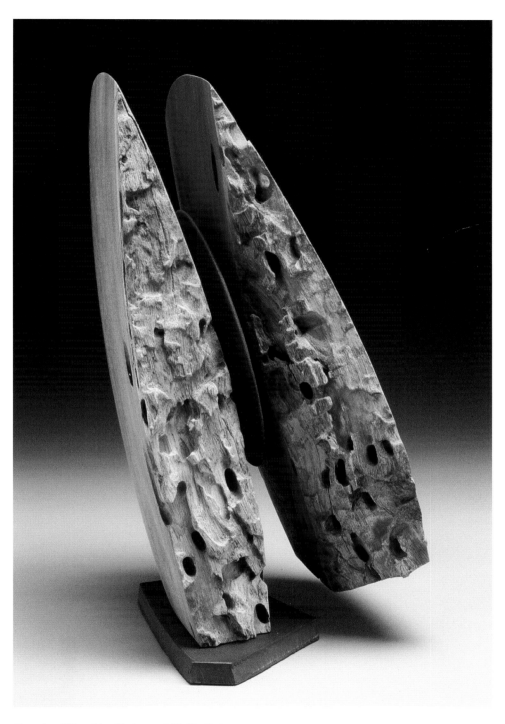

Crowning, 2001, metal and Mexican wood, 12 x 11 x 5 inches.
Courtesy of Jane and Arthur Mason. Photo by Tim Barnwell.

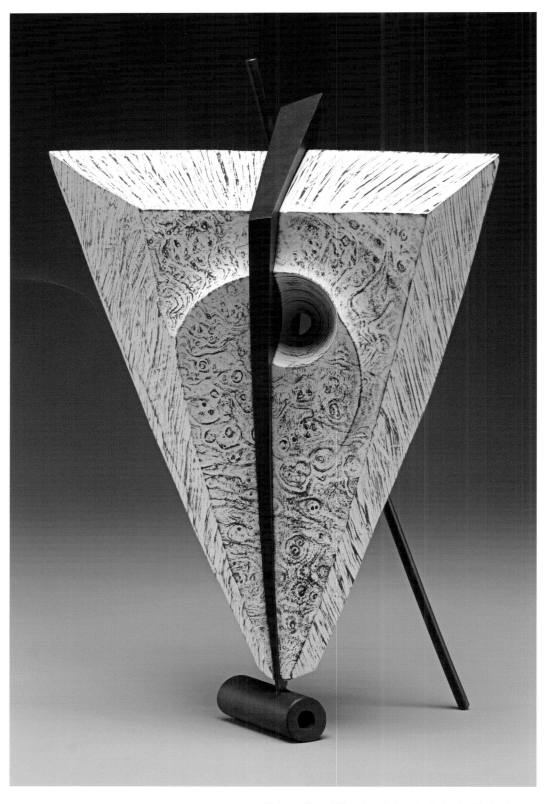

All Dressed Up, 2003, madrone burl, steel and milk paint, 22 x 14 x 6 inches.
Courtesy of the Arkansas Arts Center. Foundation Collection: purchased with a gift from John and Robyn Horn. Photo by Tim Barnwell.

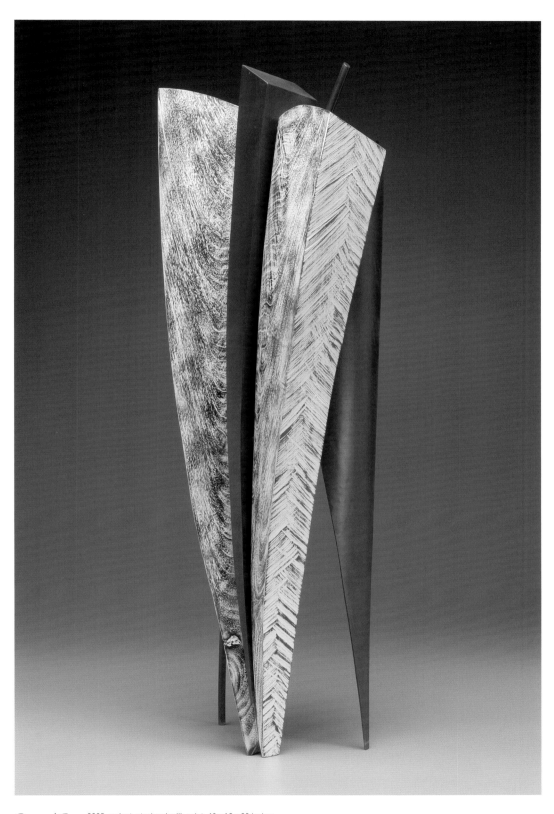

Cape and Cane, 2005, walnut, steel and milk paint, 40 x 12 x 20 inches.
Courtesy of the Asheville Art Museum. Gift of John and Robyn Horn. Photo by Tim Barnwell.

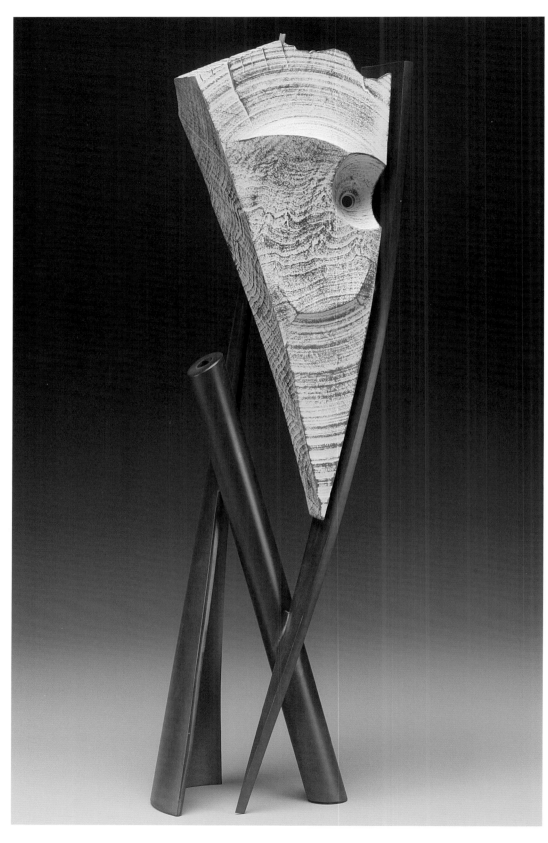

Balancing Act, 2006, madrone, steel and milk paint, 29 x 9 x 6 inches.
Courtesy of Barbara and Robert Seiler. Photo by Tim Barnwell.

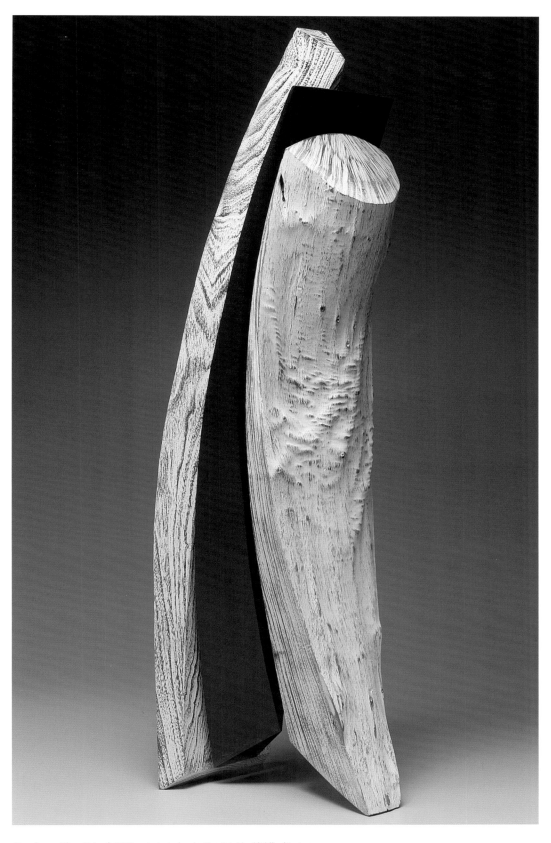

Standing with a Friend, 2006, walnut, steel and milk paint, 41 x 12 1/2 x 8 inches.
Courtesy of The Museum of Fine Arts, Houston, Texas. Gift of John and Robyn Horn. Photo by Tim Barnwell.

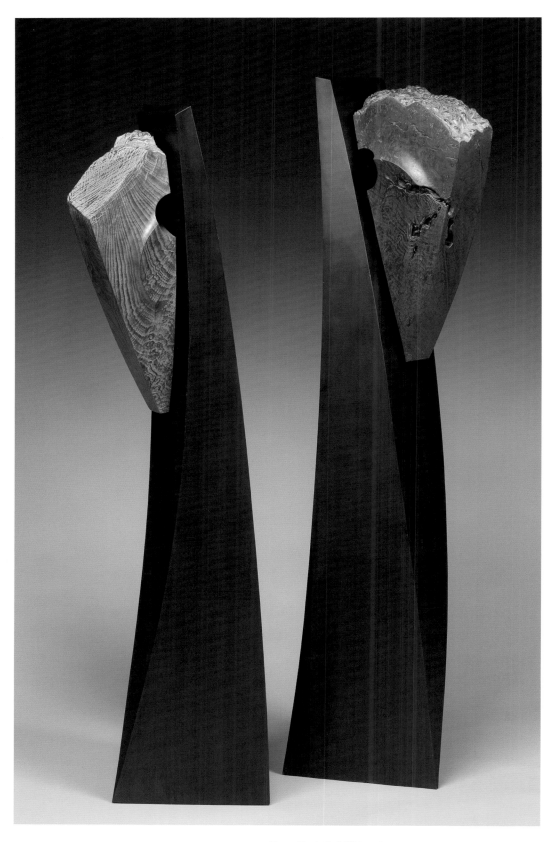

Green Eyed Girl, 2008, madrone, steel and milk paint, 53 x 11 x 12 inches.
Courtesy of Francoise J. Riecker. Photo by Scott Allen.

Blue Boy, 2008, madrone, steel and milk paint, 55 x 13 x 12 inches.
Courtesy of Jeffrey Bernstein and Judith Chernoff. Photo by Scott Allen. Detail on right.

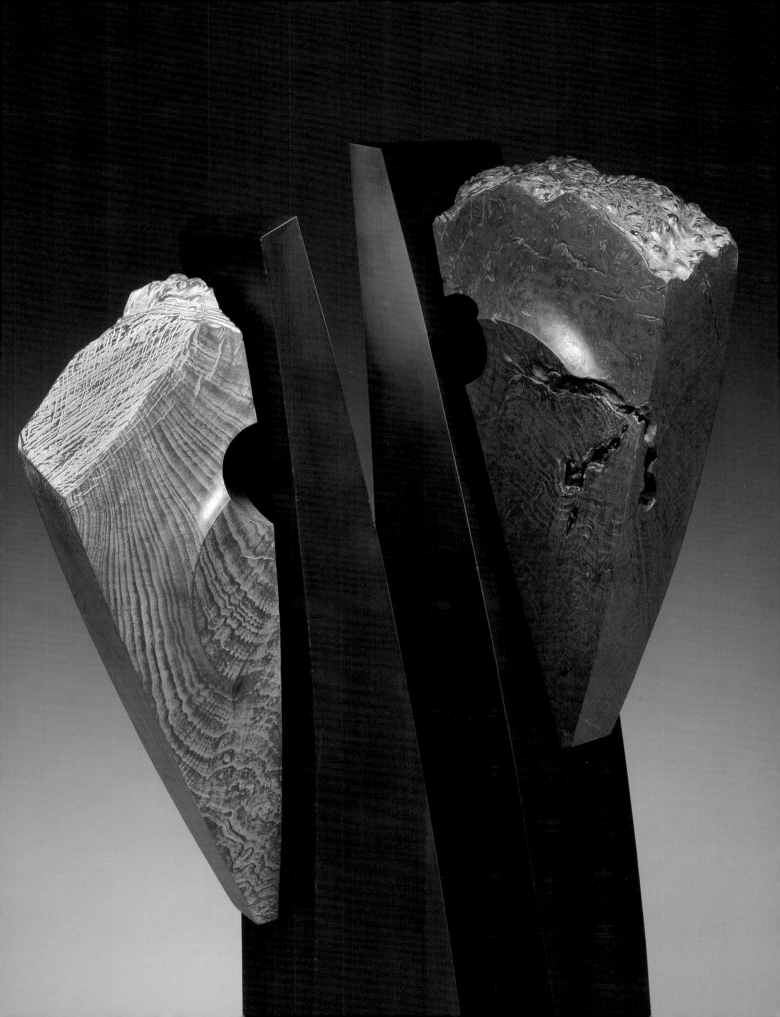

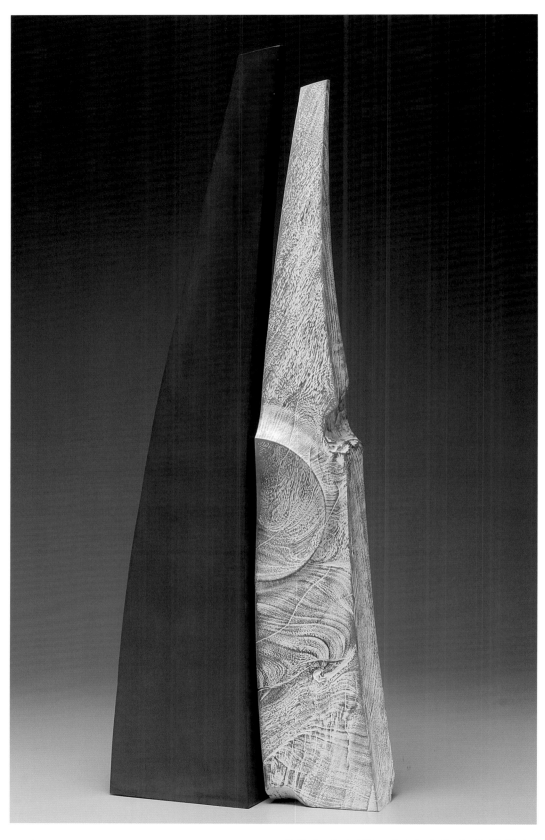

Reflection Rock, 2009, carob, steel and milk paint, 37 x 15 x 5 inches.
Courtesy of Fleur S. Bresler. Photo by Tim Barnwell.

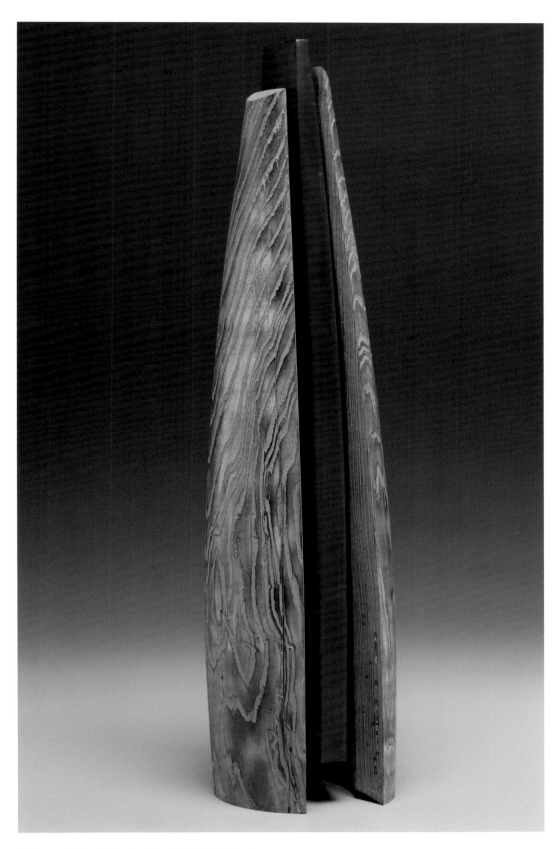

Architectural Form, 2009, ash, steel and milk paint, 36 x 10 inches.
Courtesy of Norm Sartorius and Diane Bosley. Photo by Tim Barnwell.

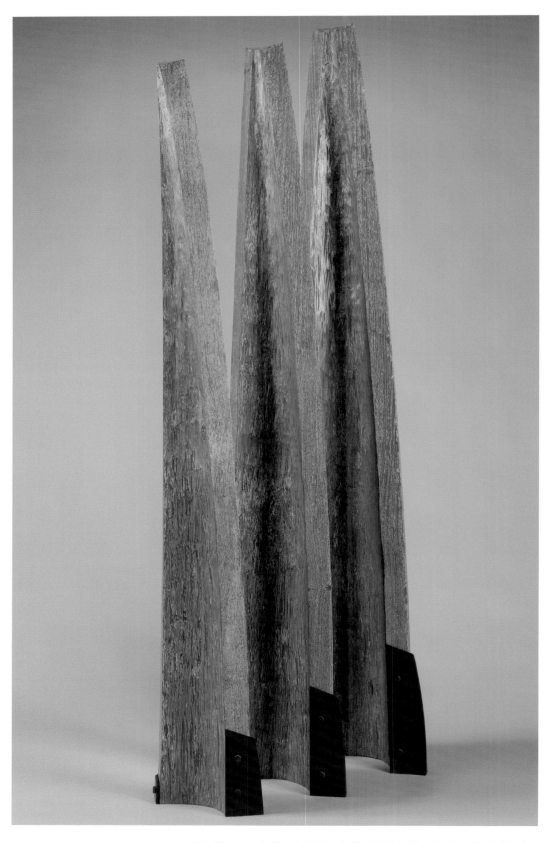

Blue Tree Shoes, 2009, walnut, steel and milk paint, (each of three forms) 70-73 x 20 x 22 inches.
Courtesy of the Asheville Art Museum. Museum purchase with funds provided by John and Robyn Horn and Blue Spiral 1. Photo by Tim Barnwell.

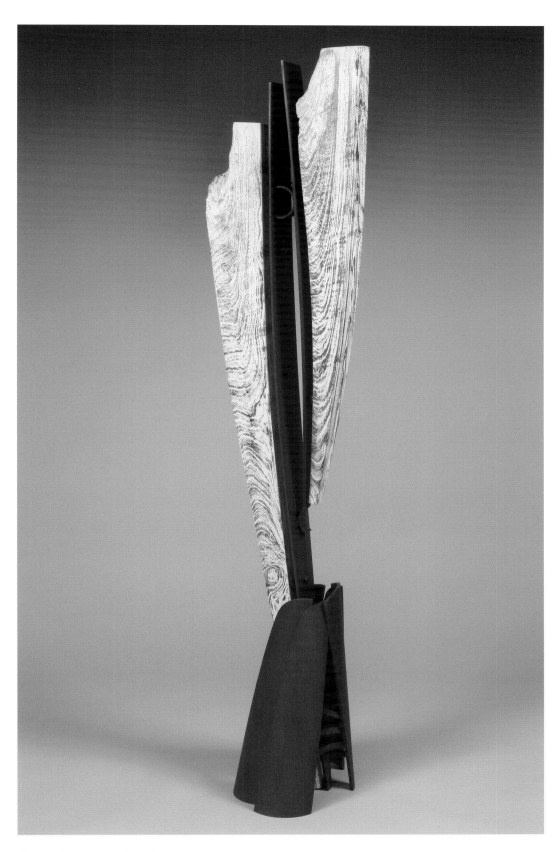

Flamenco, 2010, walnut, steel and milk paint, 68 x 14 x 12 inches.
Courtesy of Patricia A. Young. Photo by Tim Barnwell.

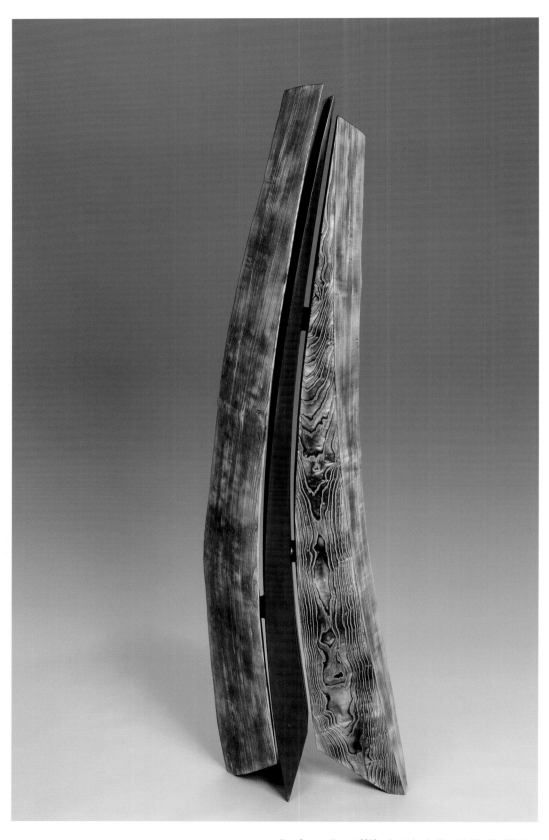

Standing in Forest, 2012, ash, steel and milk paint, 65 x 13 x 19 inches.
Courtesy of the Artist. Photo by Scott Allen.

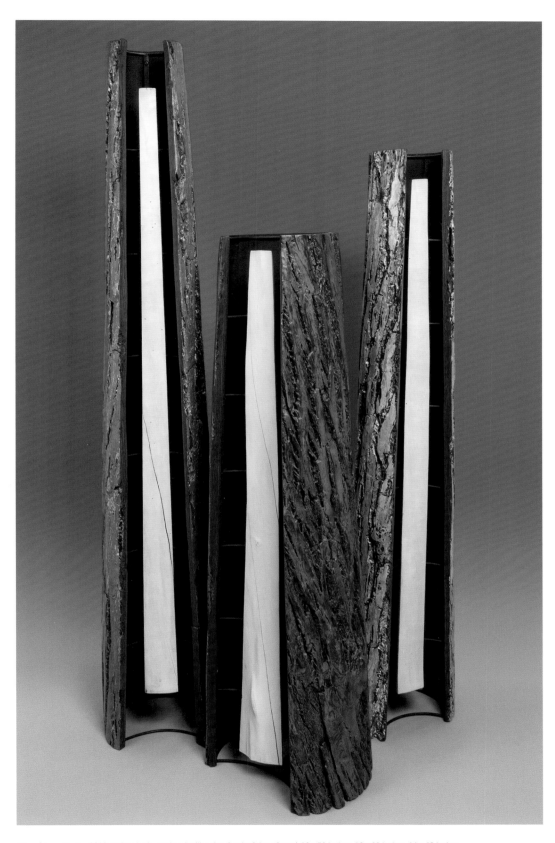

Cambium Suite, 2010, walnut bark, steel and milk paint, (each of three forms) 12 x 72 inches, 12 x 60 inches, 14 x 48 inches. Courtesy of the Artist. Photo by Scott Allen.

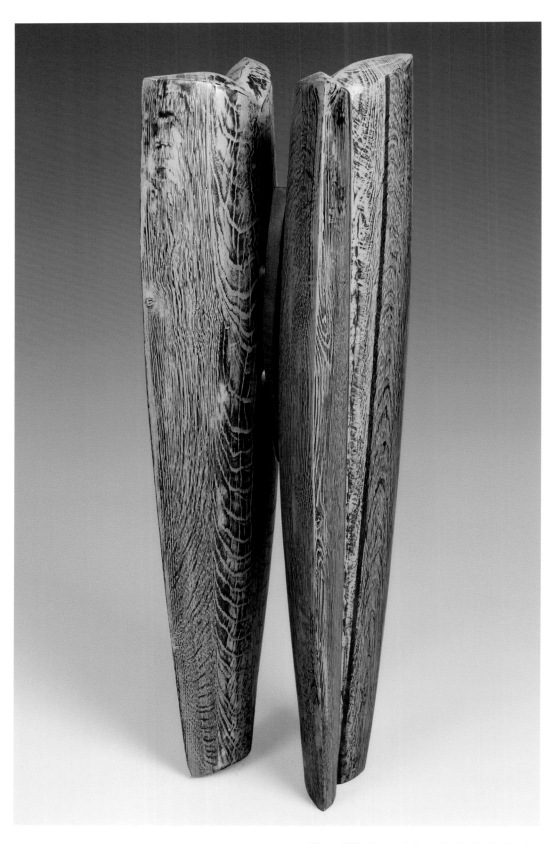

Bloom, 2012, white oak, steel and milk paint, 39 x 11 x 11 inches.
Courtesy of Leslie McEachern. Photo by Scott Allen.

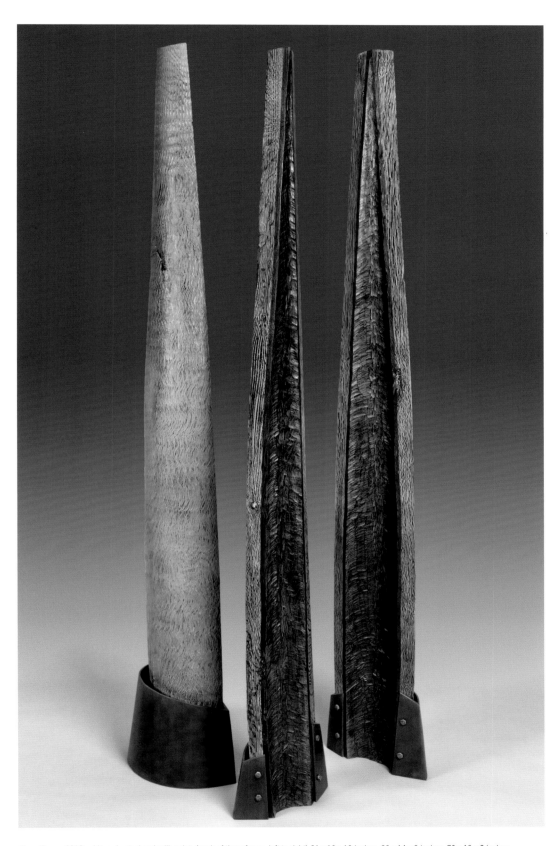

Sea Grass, 2012, white oak, steel and milk paint, (each of three forms, left to right) 81 x 16 x 10 inches, 80 x 14 x 8 inches, 79 x 13 x 8 inches.
Courtesy of the Artist. Photo by Scott Allen.

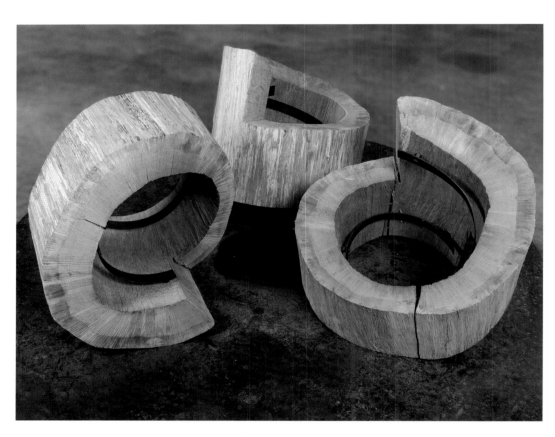

Helix 3, 2012, white oak and steel, (each of three forms, left to right) 23 x 24 x 25 inches.
Courtesy of the Artist. Photo by Scott Allen. Detail on right.

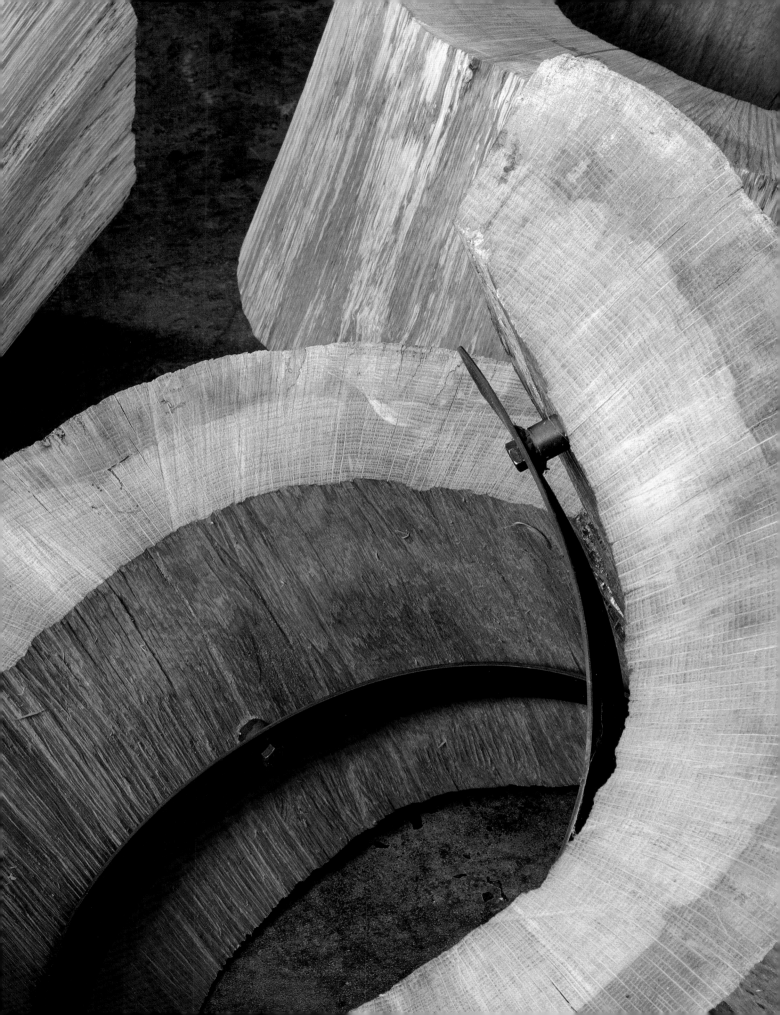

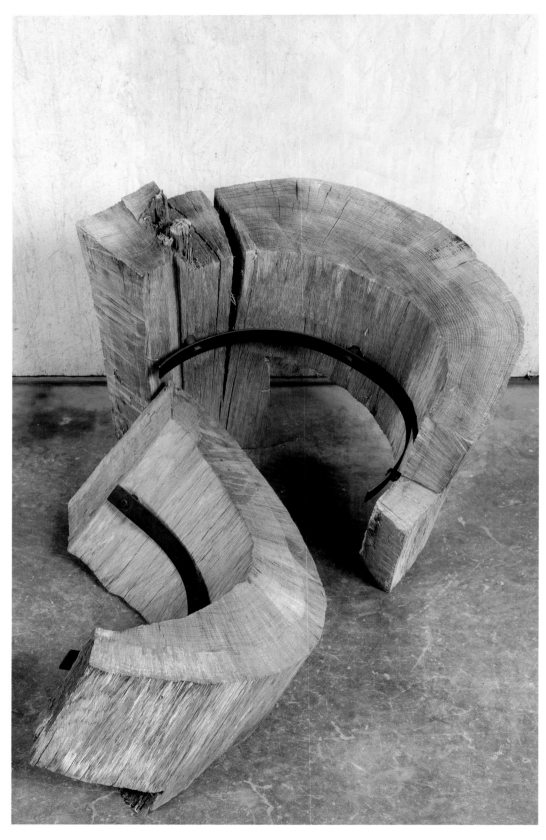

Helix 1, 2012, white oak and steel, (each of two forms) 25 x 36 x 25 inches.
Courtesy of the Artist. Photo by Scott Allen.

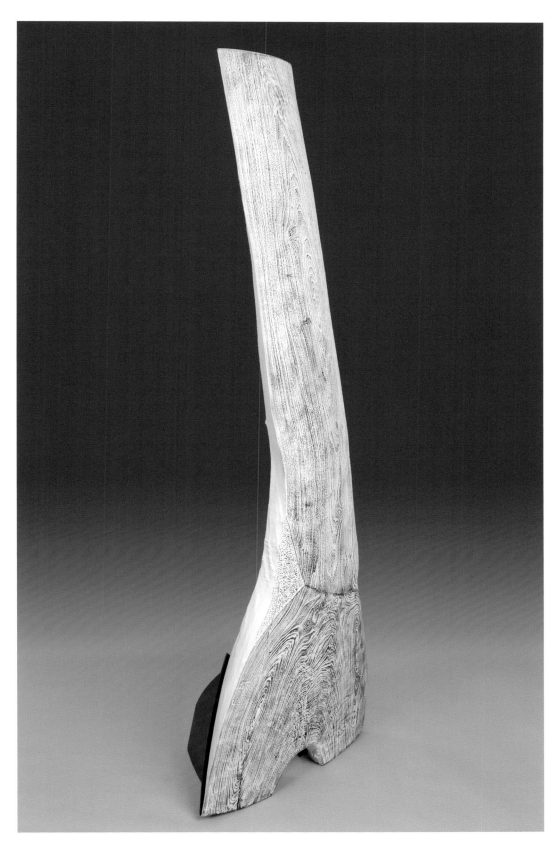

Assisted Inversion, 2012, walnut, steel and milk paint, 90 x 32 x 18 inches.
Courtesy of the Artist. Photo by Scott Allen.

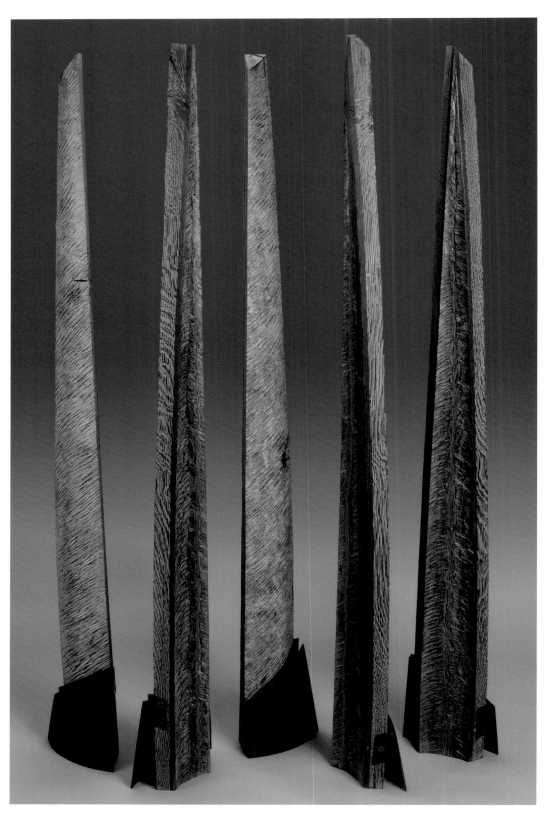

Shibori, 2012, white oak, steel and milk paint, (each of five forms) 68 x 9 x 5 inches.
Courtesy of the Artist. Photo by Scott Allen. Detail on right.

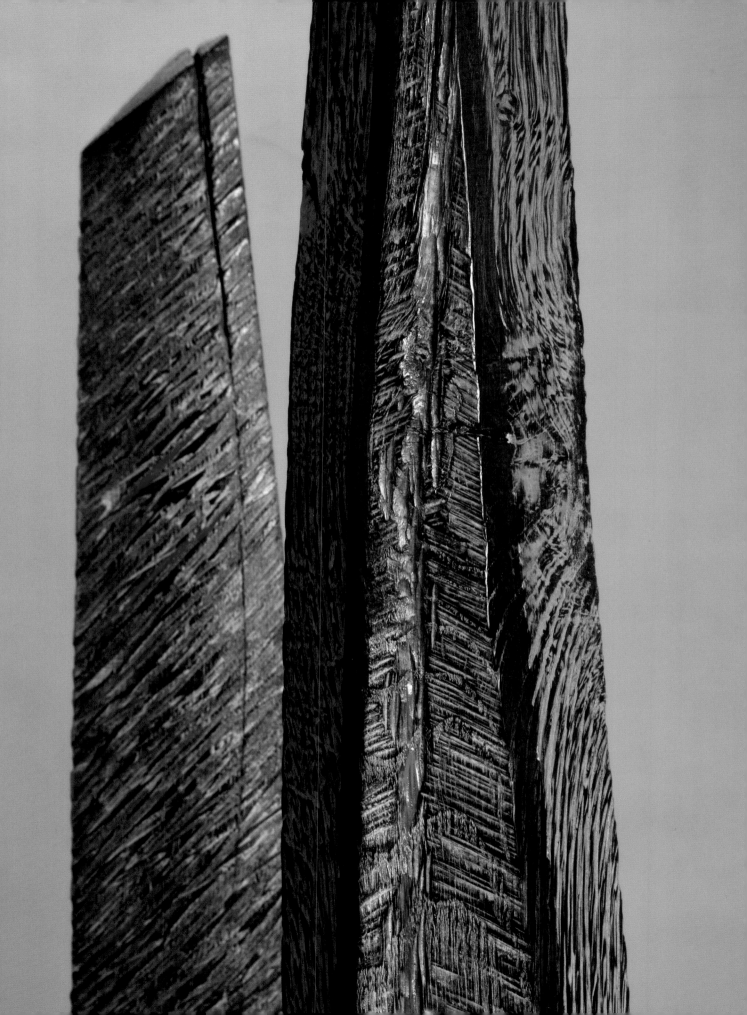

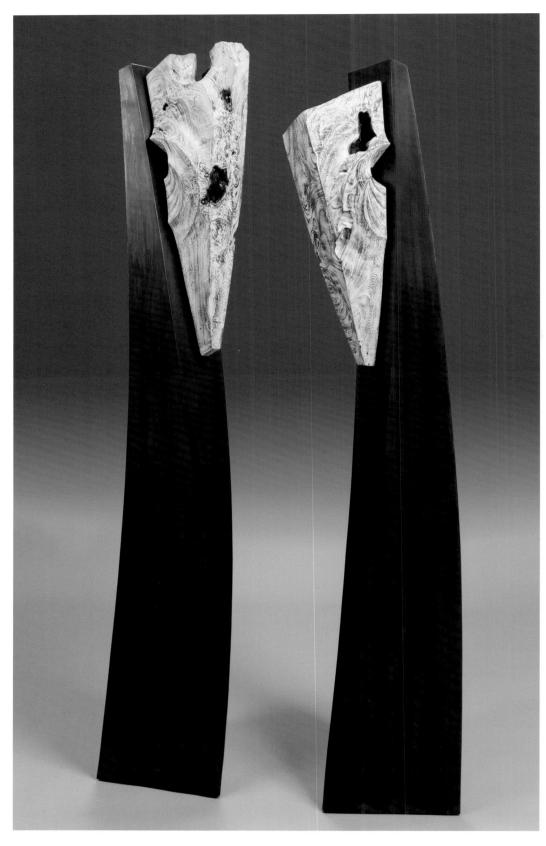

Second Watch, 2013, carob, steel and milk paint, (each of two forms, left to right) 76 x 12 x 14 inches, 74 x 12 x 14 inches.
Courtesy of the Artist. Photo by Scott Allen.

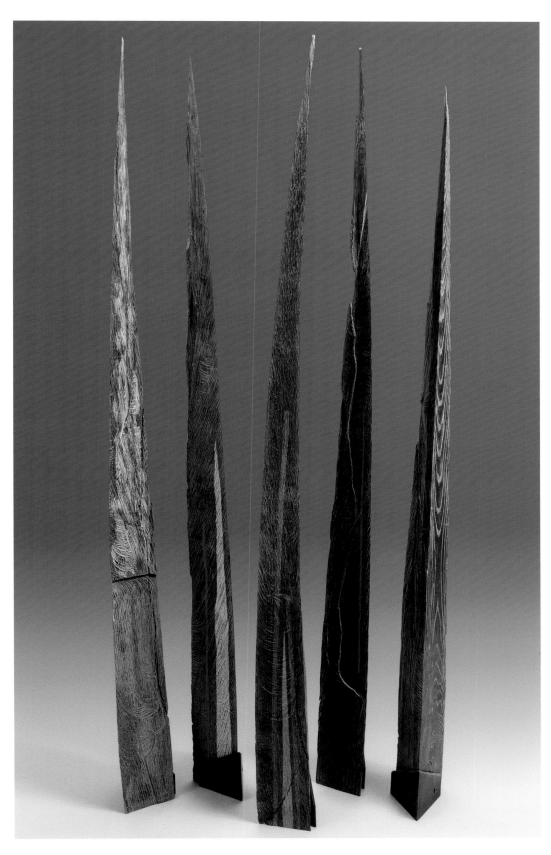

Marquette, 2013, white oak, steel and milk paint, (each of five forms) 68-70 x 6 x 4 inches.
Courtesy of the Artist. Photo by Scott Allen.

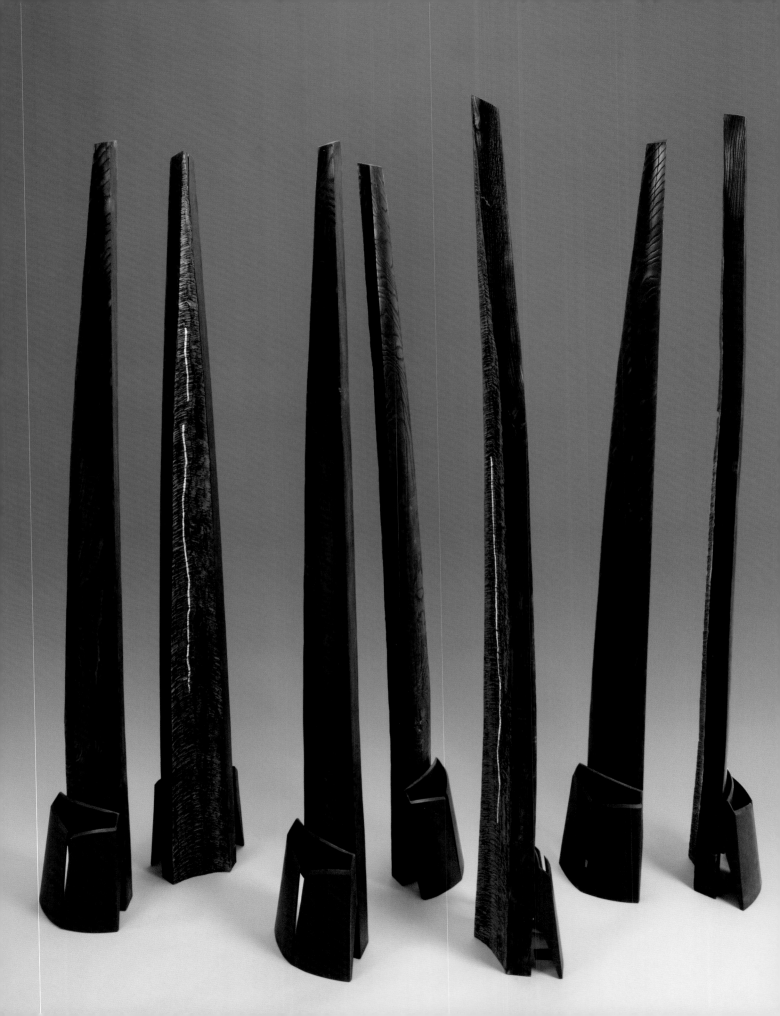

Arches, 2013, ash and steel, (each of two forms) 21 x 48 x 18 inches.
Courtesy of the Artist. Photo by Scott Allen.

Seven Sisters, 2013, ash, steel and milk paint, (each of seven forms) 68-70 x 9 x 5 inches.
Courtesy of the Artist. Photo by Scott Allen.

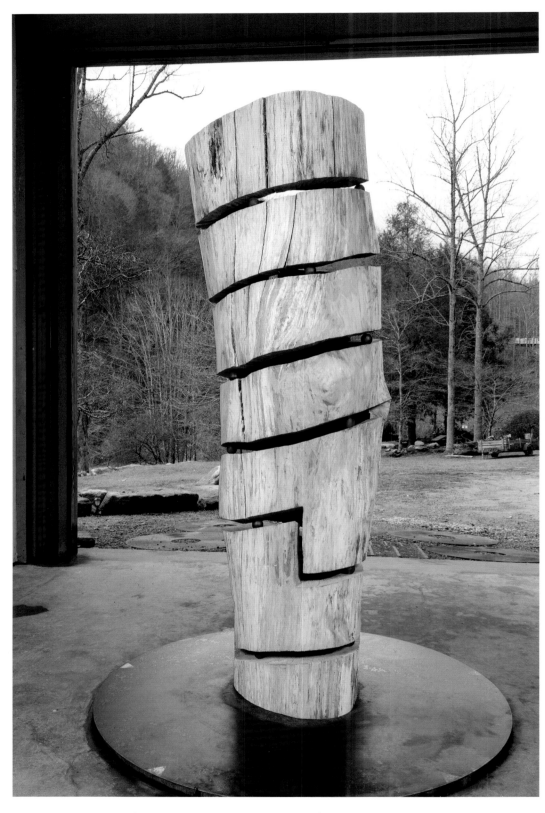

Helix Tower, 2013, white oak and steel, 114 x 32 inches diameter.
Courtesy of the Artist. Photo by Scott Allen. Detail on right.

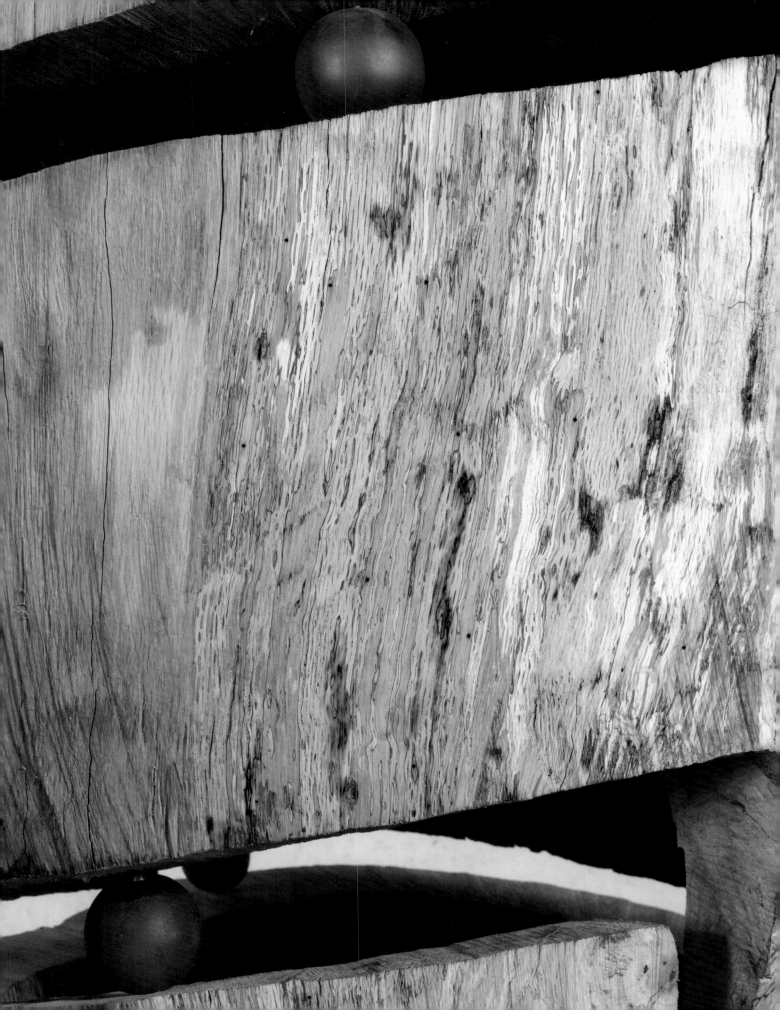

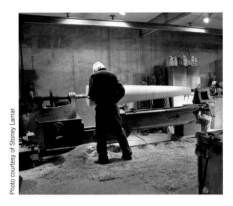

Photo courtesy of Stoney Lamar

The work of Stoney Lamar represents the body exploring its relation to the force of gravity—these sinewy forms have an acrobat's dynamism of balance through movement, and the dancer's joy in eccentric gesture. They take place in history yet aren't pedantic. His work amplifies the music in the wood. Each form is a suspension bridge placed on its end…connecting earth to sky. If our field is a body, this work is the spine, humanly upright, flexible yet strong.

Michelle Hozapfel
Artist

selected vitae

Born Alexandria, LA November 26, 1951

Formal Education

B.S., Appalachian State University, Boone, NC,
 Industrial Arts-Wood Technology, 1979
Wood Turning Workshop: Mark and Melvin Lindquist,
Arrowmont School of Arts and Crafts, Gatlinburg, TN, 1982
Wood Turning Workshop: David Ellsworth, Arrowmont School of Arts
 and Crafts, Gatlinburg, TN, 1983
Assistant to Mark and Melvin Linquist,
 New Hampshire Studio,1984 – 85

Organizations

American Craft Council, Board of Trustees, 2008
Windgate Foundation, Advisor, 2004 – present
The Center for Craft, Creativity & Design,
 Board President 2003 – 2007
 Board of Directors 1998 – present
Handmade in America, Board of Directors 1995 – 2003
Association of American Woodturners, Founding Member, 1986 – present
Southern Highland Craft Guild, 1983 – present
 President 1993 – 1995
 Board of Directors 1992 – 1995

Public Collections

Arkansas Arts Center, Little Rock, AR
Asheville Art Museum, Asheville, NC
Detroit Institute of Arts Museum, Detroit, MI
High Museum of Art, Atlanta, GA
Huntsville Museum of Art, Huntsville, AL
Long Beach Museum of Art, Long Beach, CA
Minneapolis Institute of Arts, Minneapolis, MN
Mint Museum of Craft + Design, Charlotte, NC
Mobile Museum of Art, Mobile, AL
Museum of Arts and Design, New York, NY
The Museum of Fine Arts, Houston, TX
Ogden Museum of Southern Art, New Orleans, LA
Renwick Gallery, Smithsonian American Art Museum, Washington, DC
Victoria & Albert Museum, London, England
Charles A. Wustum Museum of Fine Arts, Racine, WI
Yale University Art Gallery, New Haven, CT

Corporate Collections

Bank South, Atlanta, GA
Ethan Allen Furniture Corporation, Danbury, CT
Episcopal Diocese of Lexington, KY, Lexington, KY
Idlewild Paper Corporation, Inc., Winston-Salem, NC

Klemm Analysis Group, Inc., Washington, DC
R.J. Reynolds Tobacco Co., Corporate Headquarters, New York, NY
Salem Investment Corporation, Winston-Salem, NC

Awards

2010	Lifetime Achievement Award, Collectors of Wood Art
1995	Purchase Award, *Addicted to the Rhythm M#1*, Arkansas Arts Center, Little Rock, AR
1991	Juror's Award, *Woodturning: Vision and Concept II,* Arrowmont School of Arts and Crafts, Gatlinburg, TN
1989	Juror's Award, *Materials Hard and Soft,* Greater Denton Arts Council, Denton, TX
1985	Juror's Award, *Someone to Watch Over Me*, Arrowmont School of Arts and Crafts, Gatlinburg, TN

Solo Exhibitions

2003	del Mano Gallery, Los Angeles, CA
1998	Mendelson Gallery, Washington Depot, CT
1997	Sansar Gallery, Bethesda, MD
1995	Artist in Residence Exhibition, Kipp Gallery, Indiana University of Pennsylvania, Indiana, PA
1994	*Fall Colors,* Blue Spiral 1, Asheville, NC
1993	*Stoney Lamar,* del Mano Gallery, Los Angeles, CA
1993	*Fifth Annual Lathe-Turned Objects Show: Stoney Lamar,* Sansar Gallery, Washington, DC
1991	*Revolutions-Revelations,* Blue Spiral 1, Asheville, NC

Exhibitions

2010	*Is Ornament a Crime,* SOFA Chicago, IL, Cindi Strauss, Curator
2008	*Icons: A Tribute to Mel Lindquist,* SOFA Chicago, IL, Rakova Brecker Gallery
2007	*Speaking in Species: Space, Spectrum, and Form,* The Kendall Gallery, Kendall College of Art and Design, Grand Rapids, MI, Brent Skidmore, Curator
2007	*Craft in America: Expanding Traditions,* Craft in America, New York, NY
2006	*The Presence of Absence,* SOFA Chicago, IL, Bill Nelson, Curator
2006	*Turning Twenty: Still Evolving,* Kentucky Museum of Art and Craft, Louisville, KY
2006	*Wood Now,* Craft Alliance, St. Louis, MO
2004	*Whole Grain: Sculptural Wood,* SOFA Chicago, IL, Mark Leach, Curator
2004	*Rooted in Innovation: Contemporary Wood Sculpture,* Arkansas Arts Center, Little Rock, AR
2002	*Collectors' Choice,* SOFA Chicago, IL
2002	*Wood Turning in North America Since 1930,* Wood Turning Center & Yale University Art Gallery, New Haven, CT
2001	*Challenge VI-Roots: Insights & Inspiration In Contemporary Turned Objects,* Berman Museum of Art, Ursinus College, Collegeville, PA
2001	*Nature Takes a Turn,* Minnesota Museum of American Art, St. Paul, MN
2001	*Sculpture Invitational,* Blue Spiral 1, Asheville, NC
2000	*Turning Wood into Art: The Jane and Arthur Mason Collection,* Mint Museum of Craft + Design, Charlotte, NC
2000	Smithsonian Craft Show, Washington, DC
1999	*Collectors' Choice,* SOFA Chicago, IL
1999	Smithsonian Craft Show, Washington, DC
1999	Blue Spiral 1, Regional Artist of the Month, Asheville, NC
1998	Arida Foundation Artist of the Year Exhibition, Blue Ridge Community College, Hendersonville, NC
1998	Smithsonian Craft Show, Washington, DC

Stoney Lamar and his work have always stood out in a crowd. His tall, lanky frame is somehow reflected in his architectonic sculpture. His early work on the lathe proved that turning could yield asymmetrical results, and that the lathe was one of many great tools for implementing his innovative designs. When I saw Stoney's work in Arrowmont's 1985 exhibition, "Vision & Concept," he was branching into his winged vessel series. These were vessels raised and broadened on muscular legs. His talents, humor and insights are such great assets to the world of art made from wood.

Albert LeCoff
Co-founder and Executive Director
The Center for Art in Wood

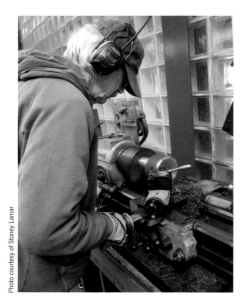

Photo courtesy of Stoney Lamar

From the minute I first viewed an image of Stoney's work in American Craft *magazine, I was hooked. The image was of a suspended vessel, and I thought the uniqueness of the work was quite spectacular. Making has always been an important part of [Stoney's] life, [he expends] enormous effort to create work that is innovative while keeping his design sense firmly rooted. He is able to convey a sense of calm, serene grace while combining cohesive elements in steel and wood. Titles such as "Torso of a Young Girl" and "Standing with a Friend" indicate [the work has] an emotional context that comes from the heart.*

Robyn Horn
Artist

1998	*Beyond Tradition: Masterworks of Contemporary Wood,* Heller Gallery, New York, NY
1997	*Moving Beyond Tradition: A Turned Wood Invitational,* Arkansas Arts Center, Little Rock, AR
1997	*Turned Wood Now: Redefining the Lathe Turned Object IV,* Arizona State University Art Museum, Tempe, AZ
1997	*Homage to Osolnik,* Connell Gallery, Atlanta, GA
1997	Smithsonian Craft Show, Washington, DC
1993-1997	*Out of the Woods: Turned Wood by American Craftsmen,* European Tour sponsored by the Arts America Program of 1997, US Information Agency
1997	*Curators' Focus: Turning in Context,* Wood Turning Center, Philadelphia, PA
1996	Smithsonian Craft Show, Washington, DC
1995	*Three Generations of Wood Turners: The Making of An Art Form,* Connell Gallery, Atlanta, GA
1995	Smithsonian Craft Show, Washington, DC
1995	*National Objects Invitational,* Arkansas Arts Center, Little Rock, AR
1994	*Turning Plus...Redefining the Lathe Turned Object III,* Arizona State University Museum, Tempe, AZ
1994	*Challenge V: International Lathe Turned Objects,* Collegeville, PA
1993	*Hand of the Craftsman, Eye of the Artist,* Hunter Museum of Art, Chattanooga, TN
1992	*Out of the Woods: Turned Wood by American Craftsmen,* Fine Arts Museum of the South, Mobile, AL
1991	*Turner's Challenge IV,* Port of History Museum, Philadelphia, PA
1991	*Woodturning: Vision and Concept II,* Arrowmont School of Arts and Crafts, Gatlinburg, TN
1990	*Lathe-Turned Objects by Robyn Horn and Stoney Lamar,* Chelsea Gallery, Western Carolina University, Cullowhee, NC
1990	*Contemporary Works in Wood, Southern Style,* Huntsville Museum of Art, Huntsville, AL
1990	*Revolving Techniques: Thrown, Blown, Spun and Turned,* James A. Michener Arts Museum, Doylestown, PA
1990	*Turned Vessel Defined,* The Society of Arts and Crafts, Boston, MA
1989	*Materials Hard and Soft,* Greater Denton Arts Council, Denton, TX
1989	*Arkansas Collects Decorative Arts,* Arkansas Arts Center, Little Rock, AR
1988	*New Talent/New Work,* Great American Gallery, Atlanta, GA
1988	*International Turned Objects Show,* Port of History Museum, Philadelphia, PA
1988	*Regional Selections,* Arrowmont School of Arts and Crafts, Gatlinburg, TN
1987	*Works Off the Lathe: Old and New Faces,* Craft Alliance Gallery, St. Louis, MO
1987	*Art in Wood,* Green Hill Center for NC Art, Greensboro, NC
1986	*American Woodturners,* Brookfield Craft Center, Brookfield, CT
1985	*Woodturning: Vision and Concept,* Arrowmont School of Arts and Crafts, Gatlinburg, TN

Teaching and Lectures

2008	Arkansas Arts Center, Artist Lecture Series, Little Rock, AR
2003	Arrowmont School of Arts and Crafts, Workshop, *Surface and Form,* Gatlinburg, TN
2002	Yale University Art Gallery, Lecture, *Wood Turning in North America,* New Haven, CT,
2002	Renwick Gallery, Smithsonian American Art Museum, *Wood Turning in North America,* Washington, DC
1998	Co-Chair, *Conference Evolution in Form: Furniture, Turnings, & Sculptural Objects,* Arrowmont School of Arts and Crafts, Gatlinburg, TN
1995	Arrowmont School of Arts and Crafts, Collaborative Workshop with Michael Peterson, Gatlinburg, TN

1995	Indiana University of Pennsylvania, Artist in Residence, Indiana, PA
1994-1995	Consultant-Fundraising, Co-Chair Wood Studio Campaign, Arrowmont School of Arts and Crafts, Gatlinburg, TN
1994	Rude Osolnik Conference, Demonstration, Arrowmont School of Arts and Crafts, Gatlinburg, TN
1994	Renwick Gallery, Smithsonian American Art Museum, *Pat and Phillip Frost Craft Lecture Series,* Washington, DC
1992	American Association of Woodturners Symposium, Demonstration, Brigham Young University, Provo, UT
1991	Rochester Woodworkers Society, Lecture and Demonstration, Rochester, NY
1990	*Transitions,* Upstairs Gallery, Tryon, NC
1990	American Association of Woodturners Symposium, Demonstration, *Vision and Concept II,* Gatlinburg, TN
1990	Brigham Young University, Demonstration, Woodturning Conference, Provo, UT
1989	Madison-Morgan Cultural Center, Demonstration, *Woodturning Southern Style,* Madison, GA
1988, 1990	Arrowmont School of Arts and Crafts, Workshop, *Woodturning: An Asymmetrical Approach,* Gatlinburg, TN
1987	Brookfield Craft Center, Workshop, *Woodturning,* Brookfield, CT
1987	Haystack Mountain School of Crafts, Monitor/Assistant, Deer Isle, ME
1987	Arrowmont School of Arts and Crafts, Teaching Assistant, Gatlinburg, TN
1987	Brookfield Craft Center, Workshop, *Woodturning,* Brookfield, CT
1987	Blue Ridge Technical Institute, Workshop, *Woodworking,* Continuing Education, Hendersonville, NC

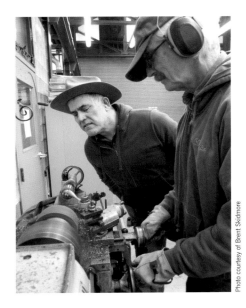

Photo courtesy of Brent Skidmore

Publications

2011	*Woodturning Today: A Dramatic Evolution,* American Association of Woodturners
2011	*Conversation With Wood: The Collection of Ruth & David Waterbury,* Minneapolis Institute of Arts
2010	*Makers: A History of American Studio Craft,* Janet Koplos & Bruce Metcalf The Center for Craft, Creativity & Design, University of North Carolina Press
2002	*Scratching the Surface: Art and Content in Contemporary Wood,* Michael Hosaluk, GUILD Publishing
2001	*Wood Turning in North America Since 1930,* Wood Turning Center and Yale University Art Gallery
2001	*Challenge VI-Roots: Insights & Inspiration In Contemporary Turned Objects,* Wood Turning Center, Philadelphia, PA
2000	*The Art of Craft: Wood,* Renwick Gallery, Smithsonian American Art Museum, Washington, DC
2000	*Turning Wood into Art: The Jane and Arthur Mason Collection,* Harry N. Abrams
1999	*Living With Form: The Horn Collection of Contemporary Crafts,* Arkansas Arts Center, Bradley Publishing
1998	*Contemporary Turned Wood,* Ray Leier, Jan Peters, Kevin Wallace, Hand Books Press
1997	*Curators' Focus: Turning in Context,* Wood Turning Center, Philadelphia, PA
1997	*Turned Wood Now: Redefining the Lathe Turned Object IV,* Arizona State University.
1993	*Lamar's Wood Sculpture...,* Daniel MacAlpine, *Woodshop News,* January
1992	*Portfolio, American Craft Magazine,* Vol. 52, No. 5
1989	*Transforming Nature's Mutations: The Turned Wood Sculpture of Stoney Lamar,* Thomas Rain Crowe, *The Arts Journal,* Vol. 14, No. 7
1988	*Contemporary American Craft Art: A Collector's Guide,* Barbara Mayer, Gibbs M. Smith, Inc.

I can safely say I would not be making the work I'm making today without having Stoney in my life. I arrived at Stoney's a wood turner and thought that was what Stoney was too. I quickly learned that the lathe, although central to Stoney's work, is just another tool in Stoney's kit.

In the world of wood turning Stoney was pushing the limits of the field 20 years ago and he continues to do so today.

Mark Gardner
Artist

artist statement

I am most interested in the exchange between my conceptual and technical vocabularies. The original development of multiple axis techniques became a way of sculpting asymmetrical forms on the lathe that led to an exploration of the power of a single line to represent gesture, attitude, and emotion. These compositions dealt both with figurative and architectural concerns that were influenced by both process and material. The addition of steel as a skeletal element to the wood forms has enhanced the narrative opportunities in the objects through the natural tensions produced between the two materials. The sandblasted and painted surfaces on the wood have become perhaps the final major addition to my sculptural palette moving the focus further away from material and emphasizing the form.

— Stoney Lamar
Saluda, North Carolina

In 1990 as I stood before "Simply Red" and
"Someone to Watch over Me", I felt the work had

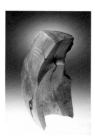

taken on a thrilling new dimension. These were the first works Stoney completed which were not vessel-referenced and although he had received much acclaim for his unconventional, multi-axis turned expressions of the vessel and I loved the elegance of some of his tall vases and the ruggedness of pieces like "All Along the Watchtower", I sensed there was something bigger going on with these new works.

My thoughts were confirmed two years later as we climbed the staircase to the Grand Salon of the Smithsonian American Art Museum's Renwick Gallery in Washington for his lecture.

Susan Casey

Someone to Watch Over Me, 1990, cherry,
18 x 8 x 6 inches. Courtesy of the Artist.
Photo by Chris Bartol.

He Calls to The Wood

and it answers. His hands rest and he waits.
He talks of summer wood, how it's soft
as rain or breath, and the wood of winter,
hard against the crack of ice, closed
and braced for what will come.

The wood waits as the lathe embraces
angles, spins them into curves, into a comet's blur,
an aleph holding time in its bright sphere,
as the sculptor holds in his arms Gabriel
of the Gate, the one he calls Arc Angle.
Slick steel draws angles in and pushes
them apart. The notes call out,
his voice responds, and into the wood
comes history, not of the tree only
but of family farms, tobacco barns,
great aunts and uncles who knew
the stories in the trees, where nothing
behaves as we expect—stories he uncovers
as he carves: The Circus Boy, Breeze,
the Queen of Hearts. Mesmerized, he sees
the trapeze arc, makes hoops and balls spin
out and bodies balance in thin air. The circus
makes a home for the oddest lives.
Inside the tent, it all makes sense,
Someone to Watch Over Me,
the longing, the story of a rock,
snow-bitten ridge, the way
we see from there; the sine of the wave,
curve of power, sweet shape
of comfort; the wilderness
where we watch and wait.

And the best story of all, the one
where our partner bows
and holds out a hand, and we hear
the very music the stars sing, and see
with the maker into the heart
of the wood…

By Susan Lefler

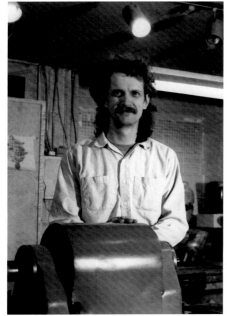

Photo courtesy of Stoney Lamar, 1985

Photo courtesy of Brent Skidmore, 2012